MAKE BETTER PICTURES

TRUTH, OPINIONS, AND PRACTICAL ADVICE

HENRY HORENSTEIN

3/22

INTRODUCTION

Make Better Pictures took five years to write, a ridiculously long period of time given its length and my familiarity with the subject. After all, I am a professional photographer, writer, and teacher. I know my subject well and can type fast. So why so long?

Barring the usual reasons my students give (procrastination, laziness, other commitments), there was the simple fact that in these five years I had actually written three versions of this book—each one longer than this. And then I threw them all out.

It wasn't that I thought they were bad. How would I know? The online reviews don't come in until after a book is published. No, they were probably good enough, but they were . . . boring. Typical. Predictable. All things I rail about in my classroom.

They were books of facts, pure and simple. And I had written books of that sort before. A few of them. Worse, there were a ton of books out there like that already. So why bother?

I decided to rethink the whole thing and write a shorter book, highlighting some of the things I've learned over the years that I think are important, interesting, worth knowing. Then sprinkle that with some pure facts and pure opinions.

In short, I decided to let it all hang out. And for toppers deliver a strong, energetic design and original, quirky drawings. And terrific, often unusual photographs by many great photographers. Some of my own photographs even. A perk of being an author.

I set out to make a book like no other in our field. Feel free to disagree, rant, or even post a negative review (though I'd really rather you didn't). But mostly, I hope you see it for what it is, and enjoy while you learn some things you maybe didn't know.

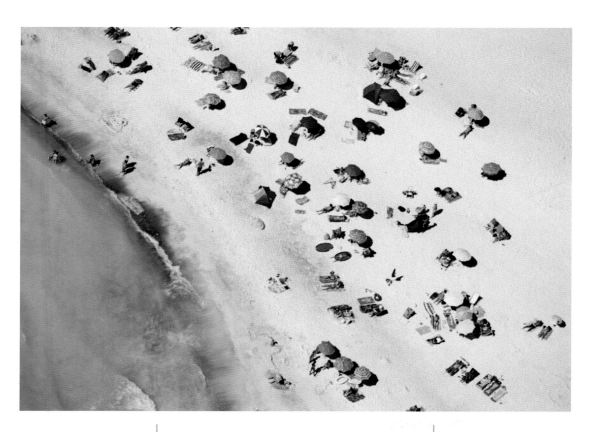

Alex MacLean has a slightly different point of view than most of us. That's because his world is thousands of feet below him, as he flies and shoots at the same time from his two-seater.

CONTENTS

MAKE BETTER PICTURES

TRUTH, OPINIONS, AND PRACTICAL ADVICE

HENRY HORENSTEIN

LITTLE, BROWN AND COMPANY
New York Boston London

MAKE
BETTER
PICTURES

TECH

"Imagination is more
important than knowledge."

ALBERT EINSTEIN, GENIUS

Some photographs have a "digital look": eye-popping sharpness, ultra-saturated color, maybe some image noise or other visual artifacts. But most images taken with a digital camera or printed digitally look a lot like traditional photos taken with film and printed in an old-school darkroom. Much the way photographer Justin Kimball worked when he began his career.

DIGITAL DEFINED

ASPECT RATIO: Ratio of the width of an image to its height.

BIT DEPTH: The amount of color information stored in a digital image. The higher the bit depth, the more color gradation.

COMPRESSION: Digitally reducing the file size of an image for more efficient use, storage, and transmission. Beware of reduced image quality when compressed too much.

DNG: A RAW file format that is universal, as opposed to typical RAWs that are proprietary.

HISTOGRAM: Graph that maps image exposure.

IMAGE FILE: The digital form of a photograph.

NOISE: Random, grain-like, and textured specks in the image, as opposed to smooth, continuous tones.

SENSOR: Light-sensitive chip that sits behind the lens in a digital camera to capture (take) the picture, providing the electronic data needed to convert the image into digital form.

ISO: Numerical rating of an image sensor's sensitivity to light.

JPEG: Information-compressed file format created by camera-applied automatic corrections.

LANDSCAPE ORIENTATION: Horizontal view.

MEGAPIXELS (MP): One million pixels.

PIXELS: Color picture elements that make up a digital image.

POSTPRODUCTION OR "POST": Work done to an image file after capture, such as cropping, sizing, and a variety of fine-tuning actions, such as work in Photoshop.

PORTRAIT ORIENTATION: Vertical view.

RAW: Uncompressed file format, retaining virtually all the information captured by the camera sensor.

RESOLUTION: Pixel count of an image file, described as pixels per inch (ppi).

KEY SETTINGS

One great advantage of digital photography is the dozens of options your camera allows. But this can also be a disadvantage. Most photographers use only a very few of these options regularly. And sometimes settings get changed accidentally, which can lead to flawed or unexpected results.

The following are the primary camera settings you should be concerned with, and an opinion on how you should set them. Feel free to deviate. Regardless of the settings you choose, these are settings you should check before every photo session to make sure they are set as you want them:

1. **IMAGE FILE QUALITY/SIZE:** RAW (or DNG) and large JPEG, if available

2. **ASPECT RATIO:** As you want it. 16:9 for wide; 3:2 or 4:3 for more square

3. **EXPOSURE MODE:** Aperture-priority

4. **EXPOSURE COMPENSATION:** 0 or +1/2 or +2/3, usually

5. **ISO:** ISO 200 or 400 in bright light, ISO 800 or 1600 or higher in low

6. **FOCUS:** Automatic

7. **WHITE BALANCE:** Automatic

8. **IMAGE STABILIZATION:** Always on, except sometimes when using a tripod

CAMERA MUSINGS

The best cameras generally offer the most features, but many of these go forever unused. The most important features, such as interchangeable lenses and RAW capture, are typically available on DSLR and interchangeable-lens mirrorless cameras. The differences are often in the quality of the features.

Professional cameras are almost always more rugged—better protected against impact, dust incursion, or water damage. Moreover, the best cameras are often paired with the highest-quality lenses. Many DSLR manufacturers make two levels of lenses—a standard and a professional model. Both will produce very good results, but professional lenses are more sturdy and should show less distortion or other optical aberrations, though you may not see these in your results, and more important they probably open to a wider aperture for better low-light capture and/or shallower depth of field.

Good lenses are important to the quality of your final result, but more important are the image sensor and processor. The sensor captures light and the processor turns that capture into an image file. The newest and physically largest sensors most often produce the best quality, and manufacturers don't put large sensors on less-expensive cameras.

Cellphone and tablet cameras have tiny sensors and simpler lenses, but many still produce good-quality results, especially for screen viewing.

Obsession with camera equipment did not arrive with the digital age. It's been with us since the beginning of photography.

GO GEEK

People come to photography for their own reasons. And it takes all kinds. Some are romantic and dreamy, while others socially conscious or practical. In most cases, people make photographs that match their interests, moods, or personality.

But there is another quite common type in photography circles—the geek. For the geek, tech is what drives them. Perhaps it's the number of the image sensor's pixels, the optical design of a lens, or hidden tricks or actions in postproduction. For the true geek, photography may be more about equipment and technique than about the image itself.

While this goes against all creative reasoning, it's not too surprising. Photography is technically driven, after all. You may or may not agree with this, but remember: geeks have rights, too. And you may even benefit from their obsessiveness. After all, who else writes the endless equipment reviews on photo blogs and other sites?

Modern digital images, properly saved and stored, shouldn't degrade, but older, casually treated images may be soft, pixelated, and off-color. This image by Bill Anderson is showing its age.

GET THE BEST

You can spend pretty much any amount on a digital camera/lens—from less than $100 to tens of thousands. Of course, you have a budget to consider and can't buy whatever you want. But in general, buy the best camera you can afford. Usually, a more expensive camera gives you better quality and more features, but it also gives you some surety that the pictures you make now will have all the quality you need in the future.

It's hard to predict the future, as technology today is so much better than it used to be, but look back at older digital still and moving images. The quality is often inferior, even when made with the best equipment available at the time. Shooting with the best now helps guarantee that your images will still look good years down the road.

This image was made with a Canon camera and a third-party lens. Technically it looks good. Would a Canon lens do better? Possibly. But other user-error factors (camera shake, poor exposure, etc.) and subject movement are more likely to impact the results than lens quality.

THIRD PARTY

What does the "best" mean when you can choose, when buying lenses, between the camera manufacturer's lens or any number of third-party models?

Not long ago, third-party lenses were strictly for bargain-hunting amateurs and poorly regarded. Their construction was often shoddy, as was their optical quality. But modern versions have made great strides, and a few are even rated better than their branded equivalents, if user reviews are any measure.

Some third-party companies even offer both standard models and pro models. And a few even offer lenses or features that comparable brand-name lenses don't—maybe advanced image stabilization or larger maximum apertures. A few third-party brands even offer old-school manual focusing along with premium optics.

Lower cost has always been the draw of third-party lenses, but costs have crept up with the addition of professional-level models. Consider a lens's features, including its bulk and weight. DSLR zooms, in particular, can be hefty, making a more compact, lighter lens very tempting. And that model may just come from a third party.

When photographers refer to the lighting ratio, it's usually, but not always, in a studio setting. This portrait of Triple Crown winner Seattle Slew has a ratio of about 1:2, which means that one side of his face is one stop brighter than the other.

STOP

The term "stop" usually refers to f-stop, a measure of the size of the lens opening. Standard f-stops double or halve the light that reaches the image sensor, so f/4 lets in twice as much light as f/5.6, and f/16 lets in half the light of f/11.

But photographers also use the term "stop" as shorthand for a general doubling or halving of light, as in: This image is a stop underexposed. Or, the right side of her face is two stops brighter than the left. Here are the usual ways the term "stop" is used.

1. **F-STOP:** As described above.

2. **SHUTTER SPEED:** 1/125 lets in one stop more light than 1/250; 1/500, one stop less than 1/250.

3. **SENSOR SPEED:** ISO 800 is a one-stop-higher setting than ISO 400, requiring half as much exposure.

4. **LIGHTING RATIO:** When light on one part of the image is twice as bright, or one stop brighter, than another part.

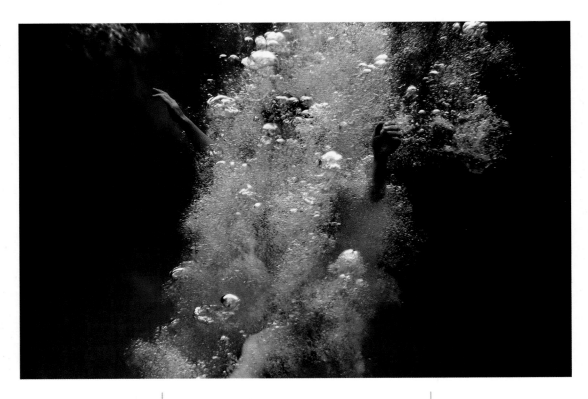

Shooting RAW, Jennifer McClure was able to pull detail from dark and light areas of this contrasty subject, making for a far richer look, with darker areas surrounding a bright center. This leads the viewer to the crux of the image.

JPEG VS. RAW

Digital cameras produce RAW or JPEG image files. As the camera's sensor captures the subject, its processor digitizes and stores it on your memory card. With JPEGs, the processed information is compressed (made smaller) as the camera automatically decides how much data to keep. With RAWs, information is uncompressed, so it allows much more adjustment in post.

The upside of RAWs is significant. Since no information is lost, it gives you far more control of the final results—more ability to darken a bright image and lighten a dark one. Or pull detail out of shadows and highlights. And so much more. Note that DNG files are RAWs that are universal, which means they can be used pretty much by all software.

JPEGs can be useful, however. They provide generally good results with minimal work, and they hog less space on your memory card and hard drive. Fortunately, many good cameras allow you to make both JPEGs and RAWs at the same time. Use JPEGs for convenience, RAWs for quality. The best of both worlds.

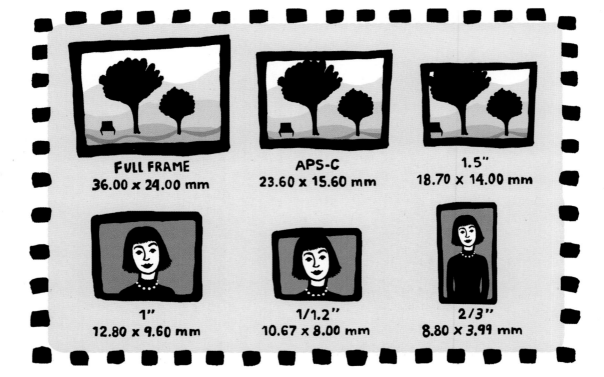

FULL FRAME
36.00 x 24.00 mm

APS-C
23.60 x 15.60 mm

1.5"
18.70 x 14.00 mm

1"
12.80 x 9.60 mm

1/1.2"
10.67 x 8.00 mm

2/3"
8.80 x 3.99 mm

Image sensor sizes vary widely, and these are approximations. But almost always the bigger the sensor the better the overall image quality—and the more expensive the camera. Naturally.

SIZE MATTERS

There are many factors that go into picture quality, but one of the most important is the size of the camera's image sensor. Large sensors almost always produce better-quality images than small sensors. Thus, most full-frame cameras trump cameras with APS-C or Micro Four Thirds sensors—and, of course, cellphones. And not all cellphone cameras have equal-size sensors either.

Even if you have, say, 24 megapixels on both a full-frame and APS-C camera, the larger sensor will usually rule because the pixels will gather light more effectively. Large image sensors contain larger individual pixels, and large pixels mean better light-gathering ability. This means reduced image noise, better low-light capture, higher dynamic range (the range between the whitest white and darkest black the camera can record), and generally more image detail/information, especially in low light at high ISOs.

Image noise happens in poorly exposed images and those taken with a high ISO (usually in low light) but rarely with perfect exposure and bright light, when you can use lower ISOs. The detail view here shows noise produced by a high ISO.

NOISE

Image noise is most likely to occur with underexposure, when too little light has reached the image sensor. But even in a well-exposed image, there are shadow areas. Because they are dark, shadow areas have less exposure and are most likely to show image noise.

Some cameras are better than others in suppressing noise in the shadows, notably full-frame and other large-sensor cameras. Also, newer models are usually better at suppressing shadow noise. Witness many of the latest smartphone models.

You can reduce image noise in shadows (or otherwise) in postproduction, but you can also help a lot when taking the picture. When framing your subject, don't include heavy shadow areas unless they are critical to the composition. You can also use flash to fill in (brighten up) the shadows. Overexposing a little also brightens up the shadows. Slight overexposure is good practice anyway, as long as your highlight areas don't blow out (start blinking).

Low-light photography usually requires a wide lens aperture, if you're not using flash. This performer was shot on stage with the lens wide open. Does it show the best possible optical quality? Who cares?

MIDDLE APERTURES REALLY BEST?

Photography techies and reviewers will tell you that the middle of the lens aperture range—say, f/5.6 or f/8—provides the sharpest and best results. Likely that's true with most lenses, especially when bench tested for optical quality. But is it really that important?

In theory, sure. But your absolute first priority should be to get the best, most interesting possible image. If you need a very small lens aperture for maximum depth of field, set the lens for f/16 or f/22. If you need a very wide lens aperture for capturing low light indoors, or shallow depth of field, set a wide f-stop, even if you are shooting at the lens's widest opening, which is often rated most poorly in terms of optical quality.

Poor results are most likely to come from user error—poor exposure, focus, or bad visual judgment. Best to worry about these things before you worry about f-stop and optical quality.

Photographing under low light means setting a high ISO, slow shutter speed, and/ or wide lens aperture. High ISO leads to image noise; slow shutter speed to camera or subject movement; and wide aperture to shallow depth of field. Here, the wide aperture and shallow depth of field worked out well, isolating the main subject and making the background soft—a nice visual effect and not at all distracting.

ISO

ISO is a rating of the image sensor's sensitivity to light. Low ISO settings make the camera electronics least sensitive; high ISOs more sensitive. So, low light levels generally need the highest ISOs; bright light needs lower ISOs.

ISO is used in conjunction with lens aperture and shutter speed. In low light, you can choose a higher ISO or a wider f-stop or a slower shutter speed intead—and in bright light, a lower ISO, a smaller f-stop, or a faster shutter speed.

You can set AUTO ISO, but it's generally best to set the ISO manually. ISO 50-100 is the lowest you can normally set; on the high end, often as much as ISO 28,000 or higher. The difference is easy math. Set at ISO 800, the camera has eight times more sensitivity as at ISO 100.

Setting the ISO manually provides more control of exposure, depth of field, and movement. But it is also the best way to control image quality. Choose a low ISO for the best quality—low noise, accurate color, high resolution.

A lens with inadequate light coverage can cause the corners of an image to vignette, which is usually not a desirable thing but sometimes works well to focus the viewer's attention into the center.

CIRCLE OF LIGHT

Light coming through a lens projects a circle of light. The size of that circle varies with the design of the lens. But mostly it links to the size of the image sensor it's meant to "cover," so it provides even light to all areas of the sensor.

Generally, lenses for a particular camera are made to cover its image sensor only—no bigger. So, if you can fit a lens made for a small sensor on a camera with a larger sensor, which is possible on some camera models, the circle of light will not fully cover the entire sensor. It will "fall off" and vignette—produce darkening on the edges and corners of the image.

Other factors may also cause vignetting, as one lens's covering circle can vary, from one f-stop to another and at different zoom settings. While vignetting is usually not desirable, some photographers like the effect. Note that vignetting can be corrected or created in postproduction.

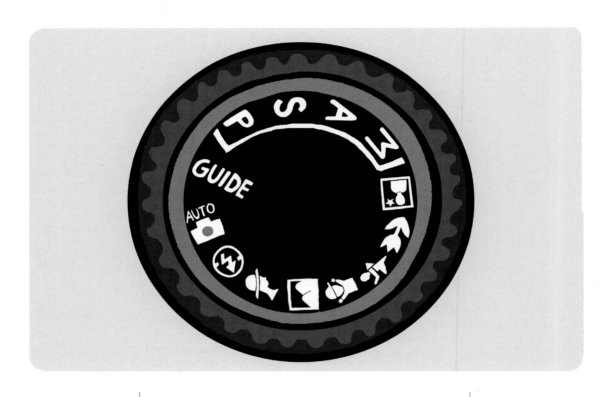

Depending on the camera, you can set auto or program on a dial, usually positioned on top of the camera or in the menu. The dial is preferable because it's easiest to set. A green rectangle or just AUTO designates total automatic; P means program. Here, A stands for aperture-priority autoexposure, not automatic.

AUTOMATIC?
PROGRAM?

Most cameras offer a choice between automatic or program autoexposure. Both are automatic modes that should lead you to generally good exposures most of the time, but they do it in different ways. Automatic is . . . automatic. Fully. On AUTO, the camera takes over and sets ISO, f-stop, shutter speed, white balance, flash exposure, etc. Just frame your subject, press the shutter button halfway down for focus, compose, and press down. Don't worry about the settings. You can't do anything about them anyway.

Program (P) is also fully automatic, only you get to make changes to each exposure. If your camera sets 1/60 at f/8, but your subject is moving, set P and change the 1/60 to, say, 1/250 to freeze the action, and the camera will reset to 1/250 at f/4 to compensate for your change. Program allows you more control. You can override the camera for one exposure only. Once you've taken the picture, the camera resets to its original automatic settings.

Using a wide-angle lens, 28mm on his full-frame camera, Lawson Little was able to produce an image in focus from foreground to background. It helped that he set a small lens aperture, which also produces deep depth of field, as does a bit of distance from camera to subject.

DEPTH OF FIELD

Depth of field is the zone from the foreground to the background of a photograph that's in acceptable focus. Within limits, you can control depth of field to render everything sharp from front to back, or to minimize focus so there's a sharp subject and a blurred foreground and/or background, sometimes called selective focus.

Usually photographers control depth of field by varying their lens aperture. But there are actually at least four equally effective ways to go.

1. **APERTURE:** The smaller the lens opening, the deeper the depth of field. F/16 produces more depth overall (sharpness) than f/4.

2. **DISTANCE:** The closer your focused distance, the shallower the depth of field. A focused subject three feet away will give you shallower depth of field than one focused at 20 feet.

3. **FOCAL LENGTH:** The shorter the lens, the deeper the depth of field. So an 18mm lens always produces more depth than a 200mm lens (at a given aperture and focused distance).

4. **ISO:** Setting a higher ISO allows you to choose a smaller aperture for deeper depth of field. A lower ISO allows a larger aperture for shallower depth of field.

FILM PHOTOGRAPHY.

THE NEW METHOD OF MAKING PHOTOGRAPHS ON THE CONTINUOUS WEB.

OUR recently perfected system of FILM PHOTOGRAPHY enables any one to take photographs without the impedimenta heretofore necessary. No Glass! No Double Holders! No Changing of Plates! Weight of Apparatus Minimized! One of our Roll-Holders, loaded with a spool of Negative Paper, and weighing 2 or 3 pounds, attached to the camera, will make 24 or 48 negatives, simply by turning a key; replacing glass plates and apparatus weighing twenty-five pounds.

INDORSED BY ALL THE LEADING AUTHORITIES:

"Delighted with Roll-Holder; shall use it exclusively for all my landscape work — shall teach its management to all my students."
W. H. PICKERING, Prof. Chemistry, Mass. Institute Technology.

"Send me Roll-Holder. Have such good luck with paper that I have given up glass plates. Seem surer of success with paper."
MAURICE PERKINS, Prof. Chemistry, Union College.

"The impossible is attained: your Improved Negative Paper solves the problem."
GEO. G. ROCKWOOD, 17 Union Square, New-York.

"Truly our day of deliverance has come."
W. H. JACKSON, late Photographer Hayden Survey.

In use by the U. S. Lighthouse Board, the U. S. Fish Commission, U. S. Coast Survey, the Canadian and British Governments, and photographers and amateurs generally. *First Medals wherever exhibited.*

A revolution in photography which is of importance to every one who has made, or would like to make, photographs from nature. Circulars free. Address

THE EASTMAN DRY PLATE AND FILM CO. 910 State Street, Rochester, N. Y.

Sole manufacturers of **Eastman's Permanent Bromide Paper** for positive printing. Prints by lamp-light. No toning. Simple, easy, certain. Send for circulars.

Until the late 1800s, it was complicated and expensive to take pictures, so almost all photographers were working pros or highly committed (and wealthy) amateurs. Then Kodak introduced a camera anyone could use with film, rather than awkward (and fragile) glass plates. Funny, that's what they say today—that everyone is a photographer, thanks to cellphones.

CHANGES COMING?

Digital technology upended the world of photography, no doubt. There are still some die-hard film shooters out there, but the world is digital, and there's no stemming the tide.

It's hard to imagine, but some past technologies have transformed the world of photography just as radically—for example, dry plate technology in the 1870s. Before then, the capture medium (generally emulsion spread on glass plate) had to be wet during the exposure or the emulsion wouldn't be sensitive enough for most shooting situations. Dry plate allowed photographers to work in natural light out of a studio and save the plates to develop later. In 1888, George Eastman introduced a snapshooter camera called the Kodak. It allowed casual amateurs to take "point-and-shoot" pictures for the first time. And in 1936, the same Kodak introduced Kodachrome—the first modern color film. Big change.

So, digital rules now, and it will for a while. But don't bet against another technology changing our world sometime down the road.

GEAR

"It is the photographer,
not the camera,
that is the instrument."

EVE ARNOLD, PHOTOGRAPHER

Jim Dow remains a film shooter, using a large camera that takes 8x10-inch film. An 8x10 camera is a big, heavy instrument that needs to be seated on a tripod. Whatever camera you use, though, you will likely get more precise framing and sharper results with your camera resting on a tripod, especially in low light, which requires a slow shutter speed that might otherwise lead to camera shake.

TRIPOD

For sharpest results, especially in low light, use a tripod. But putting your camera on a tripod doesn't always guarantee steadiness. You have to make sure the tripod doesn't move during exposure.

The bigger the camera, the bigger the tripod needed. Big tripods are heavy and usually costly, but they do provide the steadiest platform support. Avoid really flimsy models if you can, even for small cameras.

For best steadying, position the tripod on firm ground, balanced with all legs extended equally. If you need to place the camera high, extend the legs fully first. The center pole is less stable; only use it when you need even more extension.

Even when steadied, tripods can move slightly, especially with long exposures, in high wind, or if near a highway with rumbling trucks going by. Wait for the wind to stop or trucks to pass. And be careful when pressing the shutter button that your finger doesn't move the camera; use a remote control release to be sure. Alternatively, almost all cameras also have a short self-timer. Press the shutter button, then hands off until the picture is made.

Some subjects are hard to photograph candidly, like this man hanging out waiting for an Uber. Here, I positioned and parked my car strategically to keep myself invisible while I made the shot.

AUTOPOD

You may already have a substitute for a tripod that will work in certain situations: your car. Say you see a possible picture while driving. Pull over and park, if you can safely. Angle the car in position, shut off the engine, turn off the music to muffle vibrations, open the window, and put a pillow (or folded-up towel or even your hand/arm) on the ledge. Then, put your camera (or lens if it's long) on the pillow for steadying effect. Compose and fire away.

A car doesn't work as fluidly as a tripod, but it can be even more useful at times, such as when you want to shoot in places where you can't set up a tripod. It will also provide a quick getaway when you want to shoot in sketchy areas—or if you're shooting large and possibly dangerous animals!

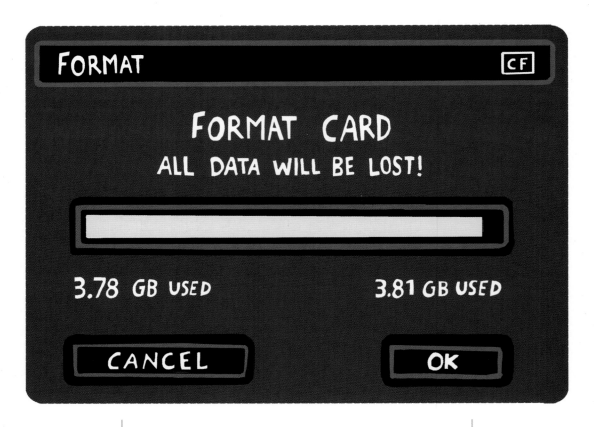

Go into the camera's menu and select format. On some cameras, you may just have the choice to erase. It's also possible to format a card in your computer. This will effectively remove all existing files, but it won't customize the card for your particular camera.

FORMAT IT

You should always format memory cards when you first use them, or if you're erasing their entire contents for reuse. This way you'll be sure that all data will be fully cleared from the card and that the card's file structure is set up most efficiently for the camera that's using it (and possibly you'll help prevent file corruption later on).

 If you plan to reuse a card that's been formatted for or used by a different camera, reformatting is especially important. And don't forget to double-check to make sure you've backed up any images that might be on the card before formatting. Or, of course, you will lose them.

MEMORY CARD BASICS

1. **USE NAME-BRAND CARDS.** They are reliable and don't cost much more than off-brands.

2. **WHEN CHANGING CARDS**, make sure your camera is turned off.

3. **USE SMALL-CAPACITY CARDS**, maybe 8GB or 16GB (16GB or 32 GB with a camera that makes large files). Much larger capacities are available and convenient, but if one fails or gets lost, you lose more than you would if you had used multiple small-capacity cards.

4. **FORMAT YOUR CARD TO YOUR CAMERA** before using it. Don't switch a card from one camera to another of a different make without reformatting it.

5. **DON'T TOUCH OR SHUT DOWN YOUR CAMERA** while it's recording images or when it's reading from the card.

6. **DON'T DELETE IMAGES FROM THE CARD DIRECTLY.** Wait till you have them downloaded and delete, if necessary, in the computer. This way you have a chance to review them on a big screen before deciding they aren't worthy of keeping. (And you also minimize the possibility, however slight, of corruption.)

7. **DON'T REUSE ANY CARD THAT'S MISBEHAVED.** Download the images from it and toss it.

RECORD AND CHARGE

Memory cards record your pictures and batteries keep your camera running—two critical functions. Make sure you treat them as such. Before going out to photograph, make doubly certain that your memory card(s) is in place and ready and that your battery is fully charged. Actually, make triple sure.

Extra memory cards are light and inexpensive. Bring a few along always. And charge your batteries after every time you go out to shoot to make sure they are ready at a moment's notice. Then, top off the charge before you shoot. An extra charged battery can't hurt—even two, if you like to hike or go anywhere electrical outlets are hard to find. Or if you have a camera that famously gobbles up battery power, as some do. An extra battery charger is also a good precaution. You may go someplace where getting a battery or charger may be difficult or even impossible, should yours go bad or go missing.

Most zoom lenses are a bit large and bulky, but not the zoom on your cellphone camera. Just spread your fingers apart on the screen to zoom in and pull the subject closer to you. Zooming may allow you to stay far enough from the subject that you don't throw your shadow on it. Use with discretion, though, as zooming can cause a noisy image and blurring. Hold steady; as with any telephoto zoom setting, or tele lens, the subject is magnified and so is camera shake.

ZOOMS RULE

Not so long ago, zoom lenses were widely looked down upon. Professionals considered their optical quality inferior. But today's zoom lenses are mostly excellent—far better than zooms of the past. Maybe some prime lenses offer marginally better quality, but you'll usually never see the difference. A far more important factor in maximizing image quality happens when the picture is taken—RAW file, low ISO, good exposure, and a steady camera/lens.

Besides, there are some subjects that can't be moved into or away from that easily. And one of the best uses of a zoom is to fine-tune the framing—make it marginally tighter or looser—just before taking the picture. And that's often far easier (and more possible) to do by tinkering with the zoom setting than physically moving close or away.

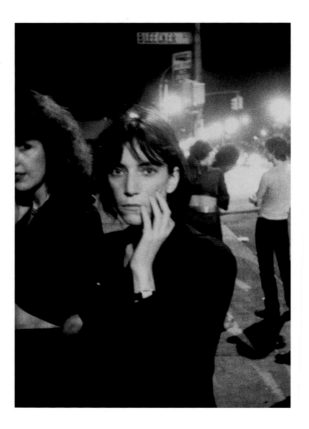

Prime lenses are great for low-light work. David Godlis shot this image with a 50mm lens wide open at f/1.4 at ISO 800. Using a zoom that opens only to f/4 would have required boosting the ISO to 6400 or so, almost certainly boosting noticeable image noise as well.

PRIMES ARE PRIME

Prime lens means a fixed focal-length lens. Lenses that have one focal length only and don't zoom. "Prime" is a bit of a misnomer, but sometimes the shoe fits. Certain prime lenses are . . . well, superior to zooms in build and optical quality. Especially the highest-quality primes, which you can usually identify the usual way—by a high price tag.

Prime lenses are almost always smaller and lighter than zooms. Less bulk makes it easier to hold a prime lens steady—less stress on your shoulder and often sharper pictures.

More importantly, prime lenses almost always offer wider lens apertures than zooms, which means more versatile low-light shooting and/or shallower depth of field opportunities. A typical zoom lens might open to, say, a maximum of f/4, whereas a typical prime lens might open to f/2, allowing in four times as much light. (Setting f/2.8 lets in twice as much light as setting f/4; f/2 lets in twice as much as f/2.8.)

Pancake lenses barely stick out from the camera body. They are almost hard to take seriously as a "real" lens. But they are indeed serious, and most produce very good-quality results at a low price.

PANCAKE

Camera lenses can be bulky and heavy, especially if they are for DSLRs. Kit zooms aren't too hefty, but longer, faster, and more sophisticated lenses are.

One good option is a pancake lens. These well-named lenses are especially light, flat, and thin. They are a bit limited. For one thing, pancakes are primes, not zooms. And they usually come in wide-angle or normal focal lengths only—not telephoto. And there aren't a lot of pancake options around, usually only one or two choices available for your model camera—if any. Moreover, some pancake lenses are manual focus only.

Still, pancake lenses are so light and unobtrusive that they can turn a relatively bulky camera into something far more portable and much less noticeable. Another advantage is that pancake lenses are faster than most zooms; some open up to a wide f/2, making them excellent choices when photographing in low-light situations.

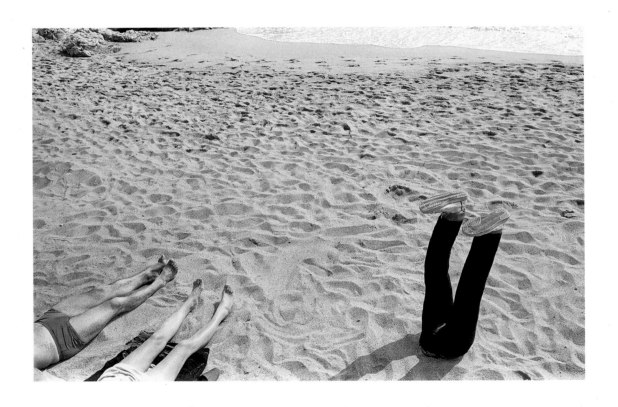

Mark Morelli obviously had to unveil his camera and lens to capture this odd beach scene. But hopefully he kept it well protected between shots until he really needed it.

BAG IT

Camera dealers offer no end of accessories to eat into your retirement savings. You can buy everything from pricey lenses to overdesigned camera bags. But for one of the most important photo accessories, you may have to head to your local supermarket for a low-cost, oversized, plastic food-storage bag. Preferably clear, heavyweight plastic with a zip lock.

The bag is for storing your cameras and lenses to keep out household dust and dirt, but especially for travel. And more especially for iffy climates (rain, snow) and where there's sand, dust, and anything else in the air that can cause damage to your expensive equipment.

Note that the image sensor is particularly vulnerable, especially if your camera has interchangeable lenses, because dust/sand can enter it while the lens is off the body. You should change lenses quickly and only in a protected area, away from wind, rain, snow, and the beach. It's always a good idea to aim the camera and lens downward as you swap lenses to reduce the chances of dust settling on the sensor.

Most zoom lenses get physically longer as they zoom out and focus close (left). Lenses with internal focusing and zooming do not (right), making them easier to handle and hand-hold without causing camera shake.

CONSTANT AND INTERNAL

When choosing a zoom lens, consider these two often neglected but valuable features: a constant maximum aperture and internal focusing.

With many zoom lenses, especially less expensive ones, the maximum aperture varies with the zoom setting. The more telephoto the setting, the smaller the maximum aperture. So a 28-200mm lens may open to a fairly wide f/3.5 when set at 28mm, but automatically close down to a sluggish f/5.6 at 200mm. A constant maximum aperture lens, say a 28-105mm that opens to f/4 no matter the zoom setting, works better for low-light shooting. It's also a more expensive choice. Very top-quality zooms may have a constant maximum aperture of f/2.8. These excel in low light, but they are even pricier, heavier, and bulkier. An f/4 zoom is a nice compromise between price and bulk.

Less expensive zooms also change their physical length as you change focus and as you zoom in and out. At the closest focus and the longest zoom settings, lenses stick out farther, making them bulkier and more unwieldy. Lenses with internal focusing and zooming, while more expensive, maintain their physical length and holdability throughout zooming and focusing.

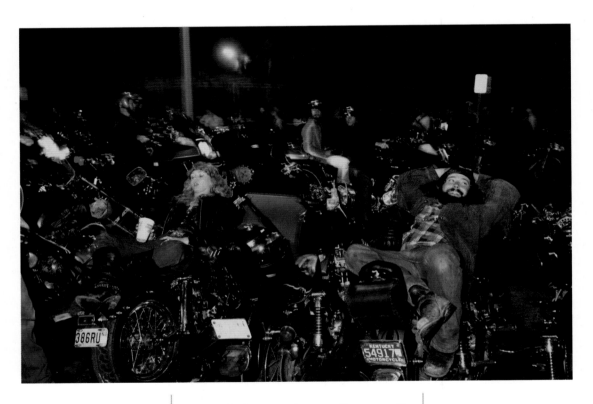

Jack Booth always carries a small camera with him, which allows him to capture subjects and situations that he would have otherwise missed. This style of shooting is sometimes called street photography.

WALK AROUND

DSLRs and some other professional-type cameras are awesome for their quality and versatility. What they aren't so awesome for is their weight and size. With few exceptions, they are both bigger and heavier and not especially conducive for the walking, meandering photographer. Even mirrorless, interchangeable-lens models, which are about half the size and weight of DSLRs, can bulk up when a lens and other accessories are added.

Enter the walk-around camera. It's not an official name, but it refers to a compact model a lot of photographers prize, even pros. Light and small, these cameras are an upgrade from cellphone shooting and a good compromise between quality and portability. Lots of pros and otherwise serious shooters have one in their toolbox so they can capture high-quality images even on a casual outing.

Many fixed-lens compact cameras are not much of an upgrade, so get one, if you can, with a large image sensor and a faster lens. A prime, not a zoom, is usually best, but there are some good models that zoom mildly. A viewfinder and built-in flash are also nice to have but are not always available on a compact. As usual, follow the money. The best models cost the most.

SHOOT

''Don't play what's there,
play what's not there.''

MILES DAVIS, TRUMPET LEGEND

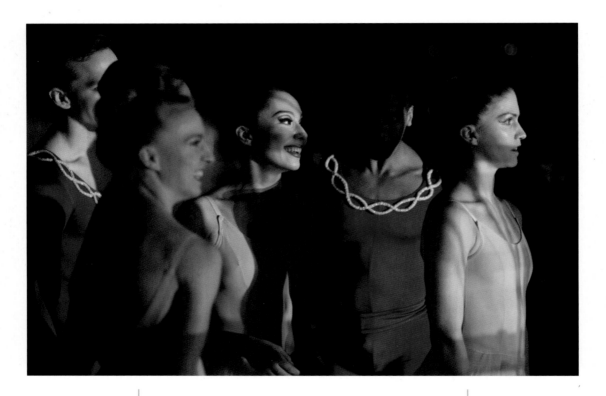

Keep your attitude natural. Encourage subjects to simply do what they do. Talk to each other. Engage each other. Or just watch what's going on. In this David Akiba photo some are in focus; some are not. Some in shadow; some bright. Maybe you'll get a relaxed and endearing picture, instead of a staged one.

LOOSEN UP

Making good pictures of people can be a challenge, even for experienced photographers. First of all, you'll probably want your subjects to look good. That means different things to different people, but it may not necessarily mean handsome or beautiful. It could mean natural, emotional, conceptual, or interesting in some other way.

One thing is for sure: if you shoot more frames you have higher odds of making an amazing picture than if you shoot fewer. Camera memory is cheap, and you can always delete pictures with blank stares or closed eyes later on, if you must. Best to do that in postproduction, not in camera, unless you run out of space on the card.

Loosen up. Make the shoot fun, not work, and let things take their natural course. Controlling situations and people is not always possible—or even desirable, so why try? Kids, for example: Tell them to stand on one leg, roar like a lion, fall into the swimming pool, or jump in midair. Or just make a loud farting noise.

Sometimes you should frame an image anticipating
its eventual use—for instance, horizontal fits best on
most monitors, just as vertical often works best on
a single magazine page or cover, which is almost
always vertical.

ORIENTATION

You can choose to photograph horizontally (landscape), vertically (portrait), or square. Usually your choice is dictated by the subject. A wide subject, such as a seascape or forest, seems to want a horizontal frame; a full-body portrait or tall building suggests a vertical. Squares are usually best for boxier subjects—balanced, static, formal.

One strategy is to frame a subject based on how it will be used. Horizontals work well for display on a computer or other screen. Verticals are natural for cellphone capture, but with larger cameras watch out, as holding a camera in a vertical position can be less stable than holding horizontal. Squares are relatively rare. Otherwise, they usually require cropping, which may impact image quality. Many older images are square, though, because many older film cameras and also iconic Polaroids were square format (though some later Polaroids were sometimes rectangular).

Different focal-length lenses or zoom settings provide different angles of view depending on the size of the image sensor. It follows that different size sensors produce different depths of field. The longer the focal length, the shallower the depth of field, and short focal lengths provide deep depth of field, such as this image with a 24mm zoom setting and a full-frame DSLR.

SENSORS AND
DEPTH OF FIELD

Image sensors in digital cameras vary in size. Most are the size of a 35mm film frame or smaller. For this reason, cameras with 35mm-sized sensors are called full frame. They conform to the same rules and relationships concerning focal length, angle of view, lens aperture, and depth of field that have always guided 35mm film photography.

Other cameras, including smartphones, have smaller sensors. For example, sensors in APS-C cameras are about one-third the area of 35mm; sensors in Four Thirds cameras, about a quarter. A larger sensor generally produces better image quality, but other technical factors can also make a difference.

Different-sized sensors need a different lens focal length for a specific angle of view. A 50mm normal focal length for full frame produces a 46-degree angle of view; to get the same normal "coverage" in APS-C, around a 30mm focal length is needed. For Four Thirds, it's just 22mm. This affects depth of field for a given angle of view. Because a full frame's 50mm normal is longer than APS-C's 30mm normal, its depth of field is shallower at a given aperture. So, in general, the smaller the image sensor, the deeper the depth of field, and the larger the image sensor, the shallower. All other things being equal.

This group of kids by Rania Matar makes a striking subject, but it's the background that helps place and describe them. And the background complements the strong color of the kids' clothing, making the subjects and the wall seem to be one.

BACKGROUND

What lurks in the background can be as important as the sub-
ject itself. It can simply act as a visual enhancement, or it can
add context or other critical information. Your subject may
look flat and dull when photographed against a white wall,
but switching to a red wall may create more dimensionality
and energy. A beautiful tree in the background may suggest
warmth, whereas a graffiti-strewn wall may say edgy.

Moreover, the complexity of the background can have a
strong effect. A simple wall will make your subject stand out,
but a street scene (i.e., the background) may cause your subject
to be lost. The same goes for landscapes, still lifes, and animals.

Sometimes busy works well to express, say, confusion or
high energy. But usually simpler, less distracting backgrounds
work best. Move your camera's position so tree branches clear
your subject's head or move your parked car for an unimpeded
view of that retro storefront. Or simply put your background
out of focus by limiting depth of field.

Shadow (dark) areas can cause exposure problems because they reflect relatively little light back to the camera's sensor. If you add a little more exposure than your meter suggests, you're more likely to capture enough light for good shadow detail (dark skin, here). As long as bright areas don't "blink," you'll also retain good detail in white parts of the subject (t-shirt here).

EXPOSE FOR THE BLINKIES

Modern cameras produce excellent results almost all of the time, even in automatic or semiautomatic modes. Even if you are off by as much as 2–3 or more stops, you can probably make it right in post, if you've shot RAW.

Problems may occur at the brightest parts of an image, where highlights can be blown out—blank brights with no detail. Similar story at the darkest parts, with empty shadows that lack detail.

Use whatever autoexposure mode, then add additional exposure; setting + on your exposure compensation dial is a good way to do this. Keep adding +1/3 or +1/2 until you see highlights blinking on your camera's screen or in the viewfinder. When you do, stop and scale back, reducing exposure incrementally until the blinkies disappear. Note that you'll probably have to set (in the menu) your camera to blink.

This technique guarantees good detail in the highlights, while maximizing shadow detail. Make sure you've got RAW files to work with, so you can adjust them as much as you need to in post. Note that sometimes highlight blinkies are inconsequential, such as with bright light bulbs in an interior scene. Ignore them. Chances are there's no detail to capture in the bulb anyway.

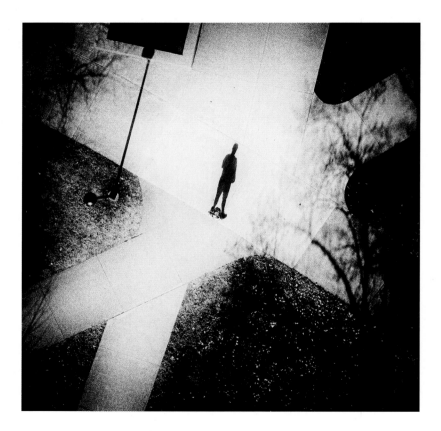

Most photographs are made at street level. See your subject; take aim; fire. But finding an unusual point of view can make for a unique image, as in this photograph by Alex Gourlay. Lie flat on the ground to shoot the family terrier or climb up on a ladder (be careful) to shoot down at kids playing on the lawn. Safer still, let a drone do the climbing for you.

GET HIGH

The most obvious situations for getting a little high are when something is obstructing your main subject—for example, a fence blocking the cows in a pasture or the front row blocking the people in back in a group portrait. Lift the camera high to make this shot, if you must. But be careful to hold it very steady when you do. A better solution is to get on a ladder to obtain a higher vantage point, enough to "see" over the obstruction and get a clear view of what's behind.

Another occasion on which you may have your shot obstructed is in clubs, when you are trying to photograph a band. You won't be able to set up a ladder there, obviously, but you may be able to lift your camera or find higher ground in the club or find a lower obstruction—a short person—to stand and shoot behind.

Another simple, lightweight option: a monopod. With your camera mounted on this one-legged tripod, you can raise your camera higher. How to focus and fire? Use a remote dedicated to your camera or connect to your smartphone with an app that lets you compose, focus, and shoot from your phone.

If you don't have a tripod handy, use a high ISO (maybe ISO 800–1600 or more), a wide-angle lens, a wide aperture, and a fast shutter speed. In almost all cases, the color should be good, the image noise acceptable (with most cameras), and the subject dead sharp, as in this image by Carl Martin.

EIGHT ROADS
TO SHARPNESS

For the sharpest pictures, you'll have to focus critically, of course, but even well-focused subjects can sometimes appear soft or fuzzy in the final result. While it's true that some lenses will produce sharper results than others, most unsharp pictures are caused by user error. So, some options to prevent this:

1. **USE A TRIPOD.**

2. **HOLD YOURSELF** and your camera super still when making the exposure.

3. **SET THE FASTEST SHUTTER SPEED** the situation allows, opening the lens aperture wide, if necessary.

4. **SET A HIGH ISO.**

5. **STAND A LITTLE AWAY** from the subject for greater depth of field, and then crop to your desired composition in post.

6. **USE AN IN-CAMERA OR ADD-ON FLASH,** even in daylight.

7. **MAKE SURE IMAGE STABILIZATION** is turned on.

8. **USE A WIDE-ANGLE LENS** (or wide-angle zoom setting), because they are easier to hold steady and don't show the effects of camera shake the way telephotos do.

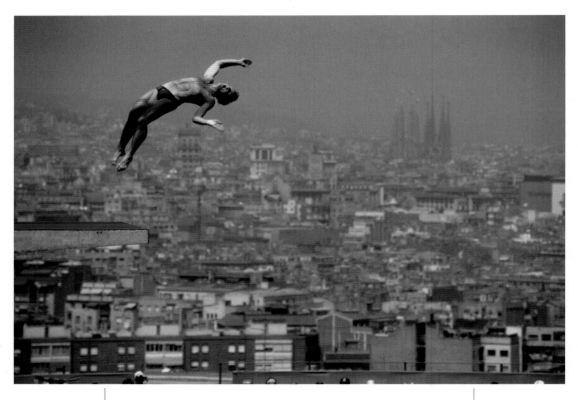

This amazing dive and other action subjects are the most obvious case in which multiple shots in succession help. A photo like this would be very hard to capture in a single shot, or in a slow-reacting cellphone, tablet, or other compact camera. Photographer Lou Jones no doubt used a camera that can capture multiple frames per second (fps).

SHOOT TWICE

Or more. When you see a picture you like, shoot once and then again if you can. That way you can be double sure that you have it right—that the camera or subject didn't move slightly and blur things, or that the file didn't somehow become corrupted, or If it's a subject you really love, maybe shoot it three times or more.

Of course, this works best for still subjects, such as landscapes and still lifes. Candid subjects and even posed portraits are hard to capture more than once. Subjects move; expressions change; eyes close. Shoot them in succession and hope your camera's capture is fast enough—or that you get more interesting results with additional exposures. Two or three frames shot in quick succession should be very similar, even if the subject is in motion. But be careful to hold the camera very still throughout the multiple exposures or the movement will cause blur. A tripod helps.

COZY UP

It can be hard to photograph strangers, or in unfamiliar environments generally. One good strategy is to cozy up to someone known to all around—for example, a bartender in a bar you want to photograph in. Go talk to him/her and explain who you are and ask for his/her OK. If given, you'll likely have free rein to shoot. You may even get a personal introduction to some possible subjects.

Once you've made a good contact, make a point of stopping by and talking to him/her—and to be seen doing it. If people in the area see you with a familiar face, they are more likely to trust you. And if they trust you, you're more likely to feel comfortable—less stressed about shooting where otherwise you may or may not be welcome.

TO DELETE OR NOT

You can easily eliminate pictures you don't like by pressing a button. It saves storage—and maybe embarrassment for your subject. It also means fewer images to manage later.

But deleting on the spot can be premature. It's hard to see well on a small camera screen, and even a poorly exposed image might be salvageable in post.

Moreover, your opinion of a savable image may change with time. That photo of a stranger standing behind your sister may have special meaning after they marry. That five-year-old Honda Civic you drove in college? It may not be a prime image, but it might bring back fond memories. Or, it could simply look very cool and downright vintage in ten years.

Goofy expressions? Closed eyes? Who cares? "Mistakes" now might improve with time or take on an entirely different meaning. Saving photos is easy and cheap. At the least, wait to delete until you see your picture well on a large computer monitor, instead of your camera's tiny screen. This will also give you the benefit of time to counter possibly rash decisions to delete on the spot.

Actually this photo makes no point at all.
Maybe just a reminder of what not to do.

CHIMP NOT

The ability to view the results immediately after exposure is one of the great advantages of digital capture. Your camera's display screen allows you to be certain of exposure, lighting, and framing. You'll know if your subject's eyes are closed or if the tree in the background appears to be coming directly out of her head. If you're not happy, simply adjust the exposure or framing, and/or reposition yourself so the tree is to the side of your main subject, and shoot again.

But immediate feedback has at least one real drawback. It's called chimping. Take a picture, look at the screen. Take another picture, look at the screen again. Like a chimpanzee.

What's wrong with this? Often, nothing. But other times you may be too influenced by what you see and lose spontaneity. Worse, you might miss pictures because you've been chimping when you should be shooting.

It's OK to chimp till you know you're on the right track with exposure, lighting, and so forth. But then it may be best to simply shoot away. Chimpless.

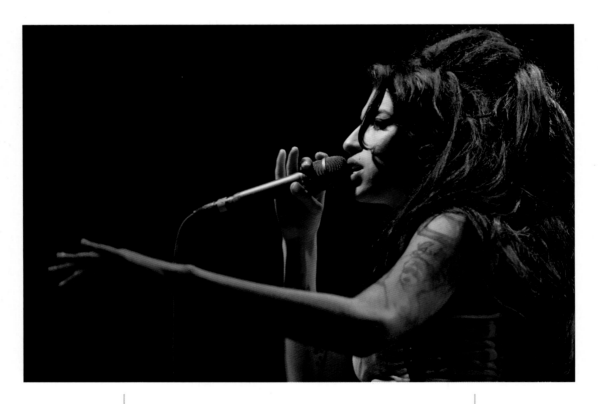

Uneven light on stage may cause your main subjects (here, Amy Winehouse) to become overexposed, causing skin and clothing to lose detail. This is especially true when much of the background is dark. Photographer Kelly Davidson compensated by giving the photograph less exposure than the camera recommended.

CLUBBING

A lot of disappointing pictures get taken at clubs and concerts. These can be difficult shooting situations even for professionals with press credentials. For the rest of us, it can be more daunting or even impossible. Some suggestions:

1. **GET AS CLOSE AS YOU CAN TO YOUR SUBJECTS.** Slide up close to the stage or sidelines to make your pictures.

2. **ZOOM MINIMALLY.** Zooming usually means a smaller maximum lens aperture, so you'll need to boost your ISO to compensate and this may lead to unacceptable image noise.

3. **USE FLASH ONLY WHEN CLOSE.** Most flash light doesn't carry very far, at most 15-20 feet or so—another argument for getting close.

4. **SET AUTOEXPOSURE COMPENSATION TO MINUS.** Often the lit part of the stage (performers) comes out too light, even "blown out." The easiest solution is to set the auto-exposure compensation scale to -1 or -2 or so. The unlit part of the stage will go even darker than it is, but the performers should be better exposed.

Placing the front of the lens flat against an aquarium's glass makes reflections disappear. If you want to position the lens differently, tilt it a little and cup the front of the lens with your left hand to block light from slipping in from the side. But be careful because thick glass can cause image distortion with a tilted lens.

THROUGH A GLASS

Good pictures can be made of subjects behind glass—for example, store windows or aquarium tanks. But reflections on the glass can ruin your shot. The best solution is to push the front of the lens flat up against the glass. The glass doesn't see anything that way, thus no reflection. An inexpensive rubber lens hood can make this easier.

Of course, you'll have to accept limits on the composition. Carefully drag the camera and lens up, down, or to the side, along the glass until you get the framing you want.

Placing the lens against the glass also helps steady the camera. Press hard enough and you'll be able to shoot at a much slower shutter speed than you'd otherwise need.

Though this technique works best if the front of the lens is flat up against the glass, it may also work if it is angled a little. But watch out for image distortion, especially with thick glass. It may also work if the camera and lens are placed a little away from the glass, if you wear non-reflecting plain, dark clothes and/or if the background is plain so it doesn't reflect light.

Most photographers like their photos in focus, but sometimes overall fuzz-iness or selective focus can be a visually exciting effect. Photographer Keith Carter's signature is ethereal and poetic images, mixing sharp and soft with shallow depth of field.

BLUR IT

Most of the time, you'll want your pictures to be razor-sharp. But who says all photographs need to be sharp? Sometimes blur is better. You can create blur in postproduction, but doing it in camera works too, and sometimes feels more natural when it does. And it saves time in post. Try these blurring methods.

1. **SHALLOW DEPTH OF FIELD.** Main subject sharp and foreground and background soft.

2. **DEFOCUS.** In manual focus mode, throw the subject deliberately out of focus.

3. **FILTER IT.** Place diffusion filters or translucent material, such as cellophane, on the front of the lens for various degrees of blur.

4. **APP IT.** For cellphone and tablet cameras, any number of blurring apps are available.

5. **SLOW SHUTTER SPEED.** For subjects in motion.

6. **PAN.** Following the direction of moving subjects at a slow speed (from 1/4 to 1/30, depending on the speed of the movement). Keep the main subject in the middle of the frame.

7. **CAMERA SHAKE.** Moving the camera during exposure, using a slow shutter speed. Fast subject movements produce even more blur.

Most photographers are a little nervous about photographing
strangers, but Richard Renaldi embraces it. And he takes it one
step further. In his series *Touching Strangers*, he asks people
who had never met each other to pose touching. The results
are often odd, funny, heartfelt, and even meaningful.

SHOOTING STRANGERS

Photographing strangers can be daunting. A lot of photographers want to do it, but almost everyone is reluctant at first—shy or nervous. They may also feel that they are being intrusive or even unethical.

Others may be afraid that their stranger will get mad or say no. If you just go ahead and shoot away, your subject won't have a chance to refuse you. And you'll likely get a less posed and predictable result.

If you do ask and are refused, you might feel rejected. But it's important to realize that it's your camera that's being rejected, not you. If you get an OK, your subject may freeze up and appear stiff, less natural. But you may have more time to make your picture and, even better, direct it (say, for best location or light), plus feeling less stressed while you're at it.

Some people are more comfortable with one approach or the other. If you like chatting with strangers, you might just ask, but if you are shy or intimidated by others, maybe try the shoot-and-run approach.

Todd Hido shot through his car window when it was dripping wet to elevate his monochromatic subject into a mysterious, impressionistic landscape.

WET WORKS

Most people protect their cameras on rainy days, wisely worrying about water damage. But you may find that rainy days provide some of the best opportunities for great results. Put your camera and other equipment in a heavy, clear plastic bag for rain-proofing, and head out to shoot.

Rainy days usually produce a bluish or monochromatic cast. Set white balance to cloudy to adjust further in post if you choose. A blue cast can evoke a strong feeling, something akin to sadness or nostalgia, which might fit well into your subject's mood. Besides, balancing color won't necessarily make for good or even accurate color. It may well cause a muddy result that's close to accurate but not quite.

Showers can also be used to produce soft or blurry results, for example by shooting through a glass window dripping with wet raindrops—again, for a moody feeling. If you don't want moodiness, shoot on a bright misty day or wait for the rain to die down and the sun to start shining through. Dampness can mix with the light to produce rich results, where the subject color becomes highly saturated—almost exaggeratedly so.

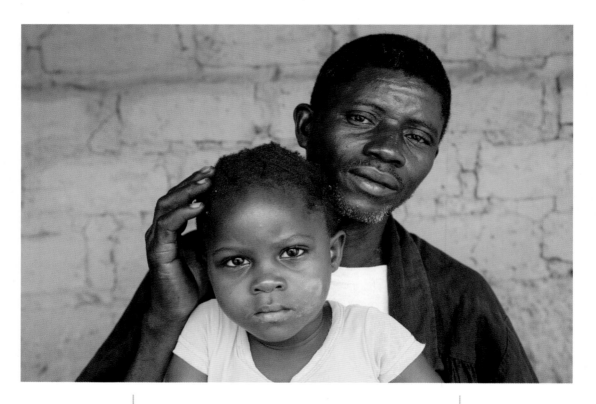

There are many ways to fine-tune exposure using automatic modes. Aperture priority autoexposure is a favorite, especially if you're shooting under low light. Set for the widest possible opening and let the camera do the rest. Here, Keiko Hiromi set a wide aperture, which put the background out of focus.

FORGET
MANUAL EXPOSURE

Modern cameras are pretty much made to be used in automatic exposure mode. Which is not to say manual settings aren't useful and, in some cases, preferable. So why do many of the fussiest photographers swear by manual settings? Makes no sense, unless these photographers were brought up on less accurate film cameras and can't be weaned off.

The usual reason given for manual exposure is better control. But you have a choice of four automatic or semiautomatic exposure modes (program, automatic, aperture priority, and shutter speed priority) with most digital cameras. And although all are at least somewhat automatic, choosing to set one or the other gives you an incredible number of options. And there are still more tools available to you. The exposure-compensation control is the best way to fine-tune autoexposure. And if that's not enough, you have the option of visual inspection thanks to the histogram and the camera's LCD screen.

OK, one exception. Studio shooters, who carefully set up shots with multiple lights and reflectors and whatever, will meter exposure precisely for the setup.

"The best pictures have to do with finding the right place to put your camera."

THE OTHER
SIDE OF THE STREET

On a bright, sunny day, the scene looks very different from one side of the street to the other. One side may be fully lit by the sun and provide bright, richly saturated color, while the shady side may produce flat, almost monochrome, or even bluish results.

It all depends on where the sun is positioned. The results are most evident during morning and afternoon hours, when the sun is low. Buildings on one side of the street will throw shadows to the other side.

Usually, pictures made in bright light are preferred. The color is vibrant and the look three-dimensional; shaded light can make subjects look flat and lacking in volume.

One strategy is to wait for a bright, cloudy day or for cloud cover on an otherwise sunny day. A wet day may also provide an extra degree of saturation as the weather improves and the sun becomes stronger.

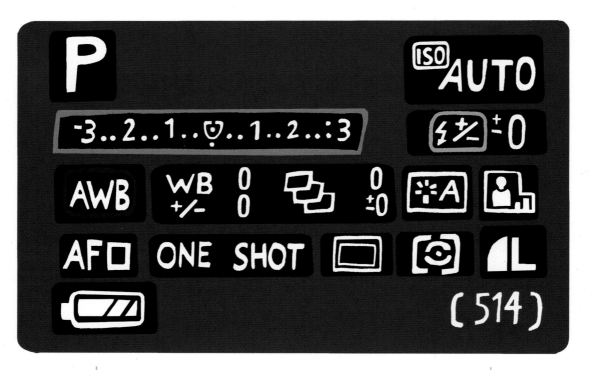

The autoexposure compensation control is probably the best way to fine-tune exposure quickly. Most photographers shoot without compensation (0) as a default. If you get a light image, set the scale for -1/2 (or even -1/3) and shoot again to make it darker. If you get a dark image, set the scale for +1/2 (or +1/3) and shoot again to make it lighter. You may also choose +1 as your default to guarantee you capture the best subject detail, but watch for the blinkies.

COMPENSATE

There are many ways to fine-tune camera exposure, including many automatic or semiautomatic choices and old-school manual adjustments of f-stop and shutter speed.

But perhaps the most useful exposure tool on modern cameras is the exposure compensation control, which is set using a scale that's usually calibrated in half or third stops. Zero represents no adjustment on the scale, and then + and - increments brighten a scene (+ for more exposure) or darken it (- for less exposure).

This scale can be found on many kinds of cameras, from some compacts to pro model DSLRs, sometimes on the camera body and, less conveniently, in the menu. It's usually the easiest way to fine-tune exposure, but only in an automatic or semiautomatic mode. In shutter priority, setting +1 retains your shutter speed choice and opens up the aperture by one stop. In aperture priority mode, +1 retains your f-stop choice and sets a one-stop slower shutter speed.

Most photographers avoid camera shake, but Jacob Berghoef embraces it, deliberately setting a slow shutter speed to make his striking impressionistic images.

HOLD THAT CAMERA

For sharp results, especially when the light is low, you should always put your camera on a tripod to steady it. But most of you won't.

The issue is camera shake, which causes image blur, especially at slow shutter speeds. Turning on your lens or camera's image stabilization feature will help, but what helps most is holding the camera rock steady. Here are some ways to ensure sharpness without using a tripod.

1. **USE THE FASTEST SHUTTER SPEED** your situation allows. An image will always be sharper at 1/2000 than at 1/8, whether a tripod is used or not. (Note you may need to increase your ISO to achieve a high shutter speed. Be mindful of noise.)

2. **USE BOTH HANDS.** Left hand under the camera or long lens, right hand on the side, with a finger on the shutter button. Never shoot one-handed.

3. **SET YOURSELF,** both feet solid on the ground, a couple of feet apart. Elbows against your body for support.

4. **HOLD YOUR BREATH,** and take the picture. Don't move before, during, or just after pressing the shutter.

5. **STEADY YOURSELF FURTHER** by leaning against a wall, tree, table, whatever, if available.

6. **PLACE THE CAMERA ON A TABLE OR COUNTER**—sort of a makeshift tripod.

7. **USE AN EYE-LEVEL VIEWFINDER TO VIEW AND COMPOSE,** if your camera has one, not the LCD screen. Brace the top of the camera against your forehead for added support.

Not looking through the viewfinder when you shoot sometimes makes the photographer invisible and can lead to surprising results—often tight, angular, spontaneous, and energetic. Here, photographer Karl Baden does a good job of leveling the camera without looking through it, which leads to a sort of voyeuristic, almost staged scenario.

HIP

Some photographers simply put the camera on their hip (or stomach or chest or . . .) and fire away. It's a dicey way to work, but it has some advantages.

It's fast and spontaneous. No need to focus critically or view. And your photos may have a special energy, as they will likely be angled up, down, or across. Moreover, the photos will be candid and you will remain invisible, which might allow you to photograph subjects you may otherwise shy away from.

Set your camera to an autoexposure mode—maybe aperture priority at f/8 (or smaller) for enough depth of field to cover slight distance inaccuracies. Or set shutter-speed priority to help freeze motion, maybe 1/125, 1/250, or faster.

If your camera allows, set the focus distance manually, as autofocusing could over- or undershoot the mark. Try four feet for close shots and eight feet for more distant subjects. And shoot like crazy. Most of the images will be disappointing, but shooting a lot should help to achieve a few very good outcomes.

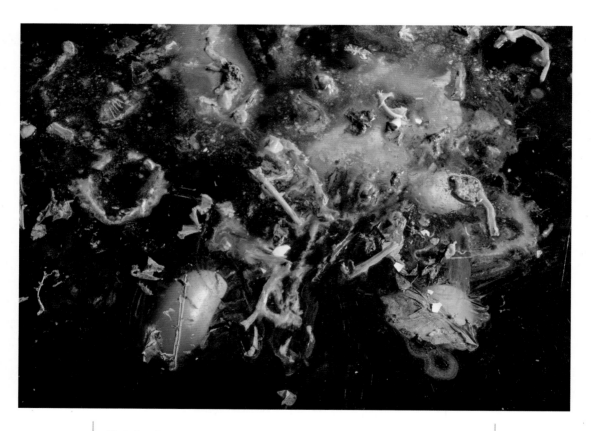

Christine Collins gets close to fragments left when dinner is done. Manual focus often works well with close subjects. Set your lens focus to manual, then twist it to a close focusing position, and move in toward your subject until you see it come into focus. Finally, adjust the close focus, if need be, and shoot away.

WHY MANUAL FOCUS?

Some photographers prefer manual focus to autofocus, but it's difficult to see why. Autofocus is almost always faster, more accurate, and less frustrating. It's particularly a blessing if you have poor eyesight.

Digital cameras and lenses are really set up for autofocus. Some compact and most cellphone and tablet cameras don't allow manual focus at all.

There are a few cases in which manual focus is preferable—for example, to combat shutter lag, the short delay between you pressing the shutter and the camera capturing the image. Autofocus worsens lag, so focusing manually allows more immediate capture. Also, consider using manual focus when autofocus is least fluid and reliable—for example, when focusing close-up or generally on shiny subjects, such as chrome, windows, or mirrors. Or low-contrast scenes or areas with little sharp detail. Think blank wall. Or when the camera wants to focus on the background instead of the main subject. Autofocus often has trouble with these.

If your camera has a viewfinder, you can probably see the subject well enough for accurate manual focus. And cameras sometimes have a viewfinder magnifier function that lets you home in on detail for more accurate focus. But if you have live view only (screen viewing), it's often hard to see well to manually focus, especially in bright light.

ALTERNATIVES

"When you play, play what's in your heart, what's in your mind, not what somebody else plays."

HERB HARDESTY, SAXOPHONIST

Russell Hart's color landscapes are shot with a specially converted DSLR that records both infrared radiation—wavelengths the human eye can't see—and visible light. These images contain a lot of red, though, so Hart just as often converts them to black and white in Photoshop, creating tones that can appear almost reversed. In color, hues can be adjusted to produce a more realistic, if still ethereal, effect.

INFRARED

Infrared film was first developed for scientific uses, but photographers quickly adopted it for pictorial effects—often described as ethereal, dramatic, or surrealistic. These effects are obtained by capturing wavelengths of radiation not visible to the eye, beyond the red end of the spectrum of light.

Digital cameras can be converted so that they capture infrared (IR) radiation. Several companies offer this service for a few hundred dollars, and it can be done to DSLRs, mirrorless models, and some compacts. The resulting images are in color by default, though the result is highly variable depending on the conversion option you choose. Some conversions capture visible light along with IR for a fuller range of color (opposite). Though reddish overall, you can tweak it in postproduction. Others go "deeper" into the infrared for a more monochrome effect.

Either way, many photographers convert the color image to black and white in postproduction. This produces images in which organic materials (grass, leaves) appear light and blue skies dark. The tones in an IR photograph are famously hard to predict—which is why digital's instant feedback is so well suited to the approach.

For his photos of Manhattan store windows, Noe DeWitt sets slow shutter speeds to capture camera movement and the effect of zooming his lens during the exposure. He often combines the two strategies to achieve a mix of streaks and smears that adds visual energy. DeWitt further broke the rules in this shot by placing a red subject against a red background—a decision that only adds to the photograph's painterly quality.

MAKE IT MOVE

Not all subjects are in motion, and sometimes static ones can seem, well, just static. One way of adding a feeling of movement to these subjects is by zooming the lens, or moving the camera, during the exposure. This often adds terrific visual energy to the photograph, in the form of streaks, lines, and squiggles. Who says it always needs to be sharp?

Use a slow shutter speed, say 1/8 or longer. Since that's still pretty short, start your zooming or camera movement before you actually press the shutter button. (Best to focus manually.) With zooming, you'll get a kind of blurry, bursting-out effect that's easier to control, and smoother-looking, if you have the camera on a tripod.

Experiment with the timing of the movement and exposure. It can be hard to predict where your main subject will end up in the frame, especially if you're moving the camera sideways. But that's the beauty of digital. Look at what you've captured and try, try again.

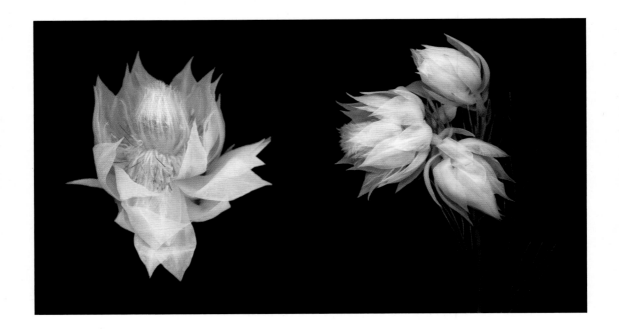

Placing your subject on a scanner instead of in front of a camera can produce striking, sometimes surprising results—interesting tonal gradations, soft/sharp effects, and so forth—but the results are often more traditional, as in these elegant floral images from Joyce Tenneson.

SCANNER AS CAMERA

Almost everyone uses a camera to make photographs. But you can also use a flatbed scanner, which is basically an image-capture device. The process is simple enough: Just place the subject on the glass bed of the scanner and click away.

1. **USE A FLATBED SCANNER** optimized for capturing photographs. Many models are made for text only.

2. **CHOOSE A SUBJECT** that is fairly flat with good texture or other detail. Think flowers, cut vegetables, feathers, and so forth. You can make striking portraits with scanners but they are rarely flattering. (Take care with your subject's eyes.)

3. **CLEAN THE SCANNER'S GLASS BED.**

4. **SET THE SCANNER AT 800-1200 DPI**, or higher for larger prints.

5. **PLACE THE SUBJECT** on the glass, positioned so the side you want to capture faces the glass. You can always adjust it later, once you've seen the results.

6. **HOLD A BOARD, CLOTH, OR PAPER SHEET** above the subject while scanning, if you want a black, white, or colored background. (This also keeps the ceiling from appearing in the image.)

7. **SCAN** and clean up as needed in post.

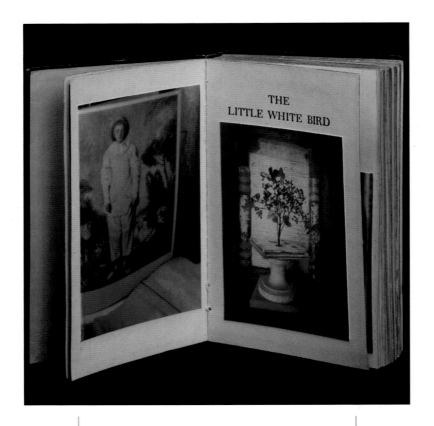

Combining images made with cyanotype, a 19th century process, with an antiquarian volume, book artist Jesseca Ferguson reinterprets a 1902 classic—*The Little White Bird* by J.M. Barrie.

LOOK BACK

You might have heard people say: "What's the point? Everything's been done before." Negative attitudes like these help keep progress and creativity at bay. A lot's been done for sure, but there's a lot more to explore and discover. People do it all the time.

One possible counter is to look at the past and rediscover and build on what's already been done. It's generally a lot more work than simple digital capture. But that's how we reap the rewards, right?

There are any number of historical processes that have been bypassed for more modern, streamlined picture-making options. And a fairly sizeable community is out there taking advantage of what so many people in the past discovered and improved. Ambrotypes, platinum prints, tintypes, wet plate. All 19th century processes that are still viable. Take a class; read up; watch a YouTube video. Sometimes what's been done can look fresh when done again.

Tom Gearty's series *Book Marks* takes inspiration from books and history. He says: "In old books, ink from the engravings often seeps into the surrounding pages and imprints a copy of the original image. These alternative images are imperfect likenesses, but they may be more accurate portraits . . . commenting on the claims, limits, and aspirations of photography."

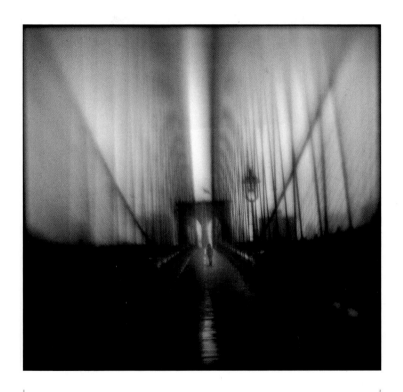

In photography's early days, before mass production, photographers usually had to make or at least customize their own cameras and other equipment. Susan Burnstine is one of a few photographers who still make their own cameras today, which she uses to express her dreamy visions—all in camera, no digital manipulation.

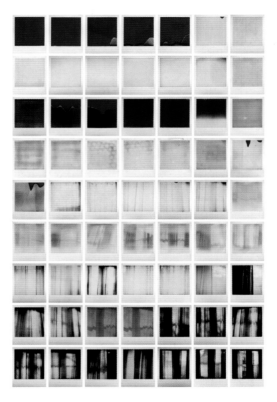

The Polaroid "look" became a staple for snapshots of friends, family, and travel. And even artists took it on to make one-of-a-kind images, including some famous names like Andy Warhol and David Hockney. Lisa McCarty used a modern Polaroid variant, once called the Impossible Project and now rebranded as Polaroid Originals, to make this grid of images from her bathroom window over a period of three years.

INSTANTS

Polaroids were introduced in the late 1940s and became a major hit among photographers (and stockholders) soon after. But along came digital photography about 60 years later, offering a better and cheaper way to make instant pictures.

Mostly people remember the iconic square image with a white frame, which developed in front of their eyes. Polaroids were one of a kind. They couldn't be easily or faithfully reproduced, unlike digital or traditional darkroom photographs.

The Polaroid brand today is just that—a brand licensed for use by the current owners of the name. The real, innovative company effectively went belly-up in the late 1990s. There remains a small but die-hard Polaroid community, and for them there are still a few options.

1. **FUJIFILM INSTAX.** A copycat of sorts, available in a variety of formats.

2. **POLAROID ORIGINALS** (new name for the Impossible Project). A well-intended attempt to bring back Polaroid's glory days, with some interesting twists and innovations.

3. **EBAY.** Occasionally sells original Polaroid material, but note that aging hurts quality. And rarity raises prices.

4. **APPS.** Various apps and software can simulate the Polaroid "look."

LIGHT

''Night changes everything.''

WILLIAM ALBERT ALLARD, PHOTOGRAPHER

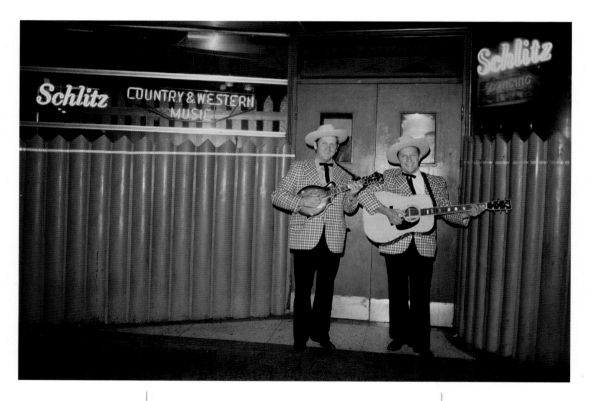

Flash is most useful when working in dim light. Rather than flash, you could boost the ISO, but that would risk funky quality (image noise). Using a flash allows a lower ISO for higher quality and also can provide even light (no dark shadows).

FLASH ON/OFF

Natural light is usually more "real" than flash. More three-dimensional, interesting, and inviting. But in low light, you may be tempted to use flash to brighten the scene because it brightens the subject for good exposure and clear detail when simply boosting ISO may not. Good use of flash does that, but it can also be harsh, flat, and lacking subtlety. It can make subjects feel like cut-out characters.

The flash effect sometimes works, if you're looking for a certain kind of impact—for example, hyperactive/goth/vampire/punk. Or it can add detail to shadow areas that might otherwise block up—go too dark. But most pictures look better in natural light. If you can get away with it, turn off the flash. Use a prime lens with a wide aperture, if need be, and push up the ISO. Use a tripod with a slow shutter speed for still subjects. Don't worry about capturing detail in every area of the image. And hope for the best.

At indoor concerts or night ballgames, you may see bursts of flash going off randomly. Unfortunately, unless you are virtually standing on the stage or sitting on the team bench, these bursts will have no effect whatsoever. The results you get will be due only to the exposure your camera would capture without flash.

LIGHT DIMS
WITH DISTANCE

The farther you are from your subject, the more flash power you need. This is because light falls off dramatically with distance. The rule, called the inverse square law, says that moving your flash or other light source twice as far away, say to ten feet instead of five, reduces the light to one-quarter of its original strength.

This is important to remember if you want to shoot from a distance with a flash. Unless your flash is very strong, the light will probably not carry. Many small flashes, for example those with your cellphone, tablet, or compact camera, may not carry far enough to be effective at more than five to ten feet.

Also, keep this rule in mind if you want to bounce light off a reflector, ceiling, or wall to diffuse its effect. Bounced light must travel from the source—the flash or other supplementary light—to the reflecting surface and back to the subject. That can be a long way to go for a flash or other light unless it is especially strong. And the reflecting surface can even absorb some of the light—a full stop worth or more.

This nightclub was very dark, so flash was used simply to produce enough light for good exposure. The picture was made "on the fly" using an on-camera flash with waxed paper taped over the bulb to soften its effect.

DIFFUSION

Light from a flash can be harsh and even brutal, especially for portrait subjects. It can create deep shadows and emphasize wrinkles and other skin unevenness. But sometimes you need the light boost that flash provides. What to do? A lot, as it turns out. There are many options available to soften a flash's harsh effect.

1. **BOUNCE THE FLASH,** if you can. Off a wall, ceiling, white card taped at an angle to the tube of a flash aimed at the ceiling—whatever's available.

2. **DIFFUSE THE LIGHT.** Commercially made diffusers for auxiliary units, if available, or even wax paper taped over the flash output with pop-up flash, cellphone/tablet flash, and inexpensive flash units.

3. **USE A RING LIGHT.** A special flash that wraps around the front of your lens for shadowless results.

 NOTE that not all of these solutions work for all flash units. For example, pop-up flash, cellphone/tablet flash, and inexpensive flash units are usually not bounceable.

Light is really prime right after the sun comes up and right before it goes down—when there is still sky color/tone to mix with the subject's light. Here, Tianqiutao Chen appropriated this eerie image a Facebook user posted just before his death for Chen's award-winning book *The Last Post*.

BEST LIGHT

You can take good pictures in most any kind of light, even in odd and difficult situations—low light, very high contrast, mixed light, whatever. So it's fair to say there is no best light. Any light can be best, or worst.

Take really bright sunny days. Light areas might become too bright and dark areas too dark. This is generally undesirable for portraits because the light may be harsh and unflattering and emphasize textures (skin blemishes and so forth). Shoot in the shade instead, and remove any blue cast in post. On the plus side, contrast can create silhouetting or add drama and mystery to a subject.

For portraits, a lot of photographers favor bright cloudy days, when there's plenty of light but no deep shadows or bright highlights. Any flat light can do the same, but the less bright the light, the more the color is likely to be funky and possibly unflattering (though often correctable in post). But then who said all portraits need to flatter?

Acacia Johnson is from Alaska and works primarily in Arctic regions. When the light is low, it produces a blue cast that creates a mysterious, quiet, and insular feeling—reflecting, one imagines, the way of life in Arctic climes.

NIGHTTIME IS
THE RIGHT TIME

The conventional wisdom is that the best natural light for photographing is early morning or late afternoon—or most any bright, cloudy day. These are conditions that generally provide the richest, most desirable, and often accurate light for your pictures. They also provide, "openness," detail in most parts of the subject without deep shadows.

Night light is less predictable. It often contains a variety of mixed light sources, including windows, streetlights, neon, and even sky, when it's not pitch-dark. Moreover, digital cameras are extremely sensitive to a much wider variety of color than you can see. So the results are often a surprise—sometimes a pleasant one.

Exposure is a little tricky in such light, but much less with digital capture than when photographing with film. At least you can see what you get and correct as you go. These are some of the important things to remember about night exposure.

1. **TRIPOD.** Usually advised.

2. **HIGH ISO.** Possibly very high, but definitely necessary if you're not using a tripod. Beware of image noise.

3. **ADD EXPOSURE.** For enough detail in the subject's shadows or dark areas, even when the meter and LCD screen say go, you might want to give it a little more—a wider aperture, a slower shutter speed, or a faster ISO.

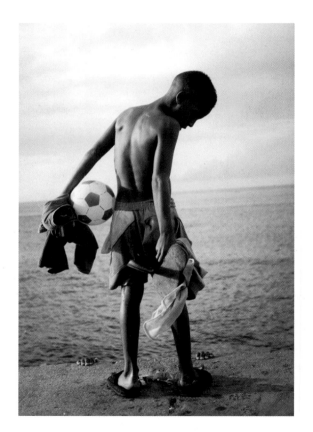

Overlooking Havana's Malecon, this kid was partially backlit due to deep shadows on him and bright light coming from the ocean and sky. A little extra exposure (+1) was enough to guarantee good exposure, especially in the shadow (dark) areas of the subject.

BACKLIGHTING

In old-school photo instruction manuals, a primary rule was: "Shoot with your back to the sun." This was to guarantee your subject would be fully lit, not silhouetted. But who says there'll be sun when you shoot? For that matter, who needs rules anyway?

Backlighting occurs when the sun is directly behind the subject, when the subject is standing in front of a window, or when a sky is prominent in the frame, effectively putting your subject in shadow. Or really any time you are facing any light source, including artificial light. It can be a nice effect, but it's generally best avoided unless you don't care about capturing good subject detail. Which sometimes you don't.

Here are some ways to counter backlighting:

1. **WAIT** until clouds cover the sun and the light evens out.

2. **MOVE** so skies and other sources of strong light are not in the frame.

3. **OVEREXPOSE** to lighten the backlit subject. Often the easiest strategy is to set the exposure compensation scale to the plus side—for mild backlighting +1 or, for more extreme, to +2 or more.

4. **USE A FLASH** or a reflector panel to "fill in" the backlit subject with light.

SEE

"You can take a good
picture of anything.
A bad one, too."

WILLIAM EGGLESTON, PHOTOGRAPHER

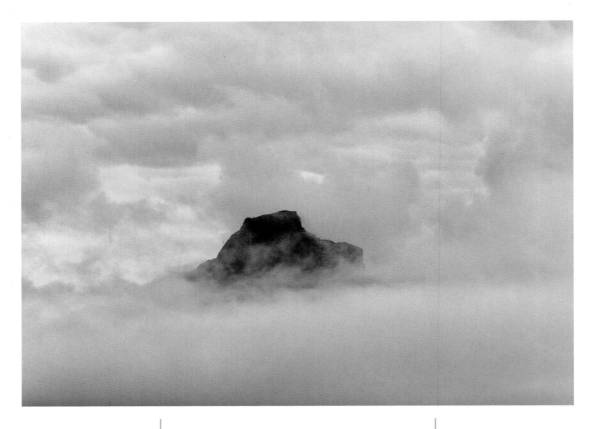

Neal Rantoul likes foggy days. Their relatively low contrast means good exposure is easily achieved with plenty of detail—no bright highlights to blow out or dark shadows to clog up.

FOGGY

You can make good pictures in any light, even dreary light. Foggy days, for instance, can produce beautiful results— soft, subtle, and subdued—moody, misty, monochromatic, even mystical.

If the fog is heavy, your subjects may be a bit indistinct. For more clarity, focus close to a strong subject and the background should almost disappear—a nice effect. If you prefer the vagaries of distant fog, choose a main subject that is farther away.

Note that bright, foggy scenes can cause underexposure. Increase exposure to enhance "fogginess." Best to work fast, as fog can turn quickly to rain, in which case you may need weather protection for your camera and yourself: your lens cap plus a clear or UV lens filter or even a heavy plastic bag or a commercially made equivalent. Shoot from a shaded or otherwise protected place, and for protection make sure to take the camera out only long enough to make your shot.

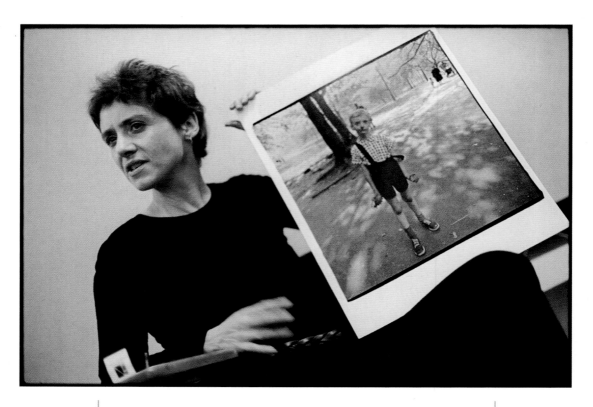

Stephen Frank took his iconic image of photography legend Diane Arbus as a student, when Arbus visited his MFA class at Rhode Island School of Design in 1970. A casual shot, perhaps, but Arbus died a year later. Had Frank not brought his camera, or been too shy to shoot, we would have missed this classic remembrance of one of the most important artists of her generation.

TAKE IT NOW

If you see picture potential in a building or sign, or maybe some people hanging around a mall, take out your camera and make the picture on the spot. If you don't take it now, you'll probably never go back to it. Chances are you'll forget, get lazy, or "it" may not be there anymore—buildings get renovated, signs taken down, people move.

There's no real excuse for not taking the picture because cellphone cameras are almost always available, if only to remind you to return with a better camera. And there may be reasons to return and reshoot (with a better camera), such as bad lighting. Let's say a building is backlit and you want to show it with better detail. Come back and reshoot when clouds even out the light. Or maybe there's a car blocking a good view of a building. Return repeatedly till the car is gone and then take your picture.

Getting closer to your subject makes a photograph more intimate, and it is also more revealing. And, sometimes, surprising.

CLOSER

One of the biggest problems photographers have is simply getting close enough to their subject. Sometimes they are shy, other times unimaginative or simply lazy. Look carefully at your subject on the camera's LCD or through the viewfinder. Would the image benefit by tighter composition? Often it will, so move closer physically or zoom in to fine-tune the framing.

A wider view works for a lot of subjects, for sure, but it is a more distanced view. It may describe your subject well, but it also may make him, her, or it unreachable or unattainable. A close view will get you more in touch, for better or worse. It can make your subject scary or intimidating or create intimacy—just as standing physically close to a human does.

Getting very close to your subject makes a strong statement—sometimes intimate, sometimes intimidating. But always present. Elinor Carucci's powerful family images do all that and more. No surprise that her first book was titled . . . *Closer.*

CLOSER STILL

Most lenses don't allow you to focus really close. They can't focus closer than 18 inches away or so, even farther with tele lenses (or zoom settings). But some models can focus on much closer subjects, maybe a few inches away. Close-up photography is called macro. With some cameras, it's controlled on the lens, and with some, in the menu.

Note that one lens may focus closer than another. True macro usually means a 1:1 view (also called reproduction ratio). This means that you can focus close enough to your subject so the image on the sensor is life-size. If you can't get that close, and the focused subject is, say, half life-size or a third life-size, then the reproduction ratio is 1:2 or 1:3.

There are other ways to focus macro without paying for a pricey lens. For example, there are less expensive close-up tubes. But the easiest and most affordable option is to place a close-up filter, really a magnifying glass, on the front of your lens.

Wide-angle lenses or zoom settings make your subject appear to have more depth. That effect makes them popular, for example, with real-estate agents trying to make small rooms look big. Or photographers trying to exaggerate the size of a kitschy theater lobby.

GO DEEP

The world is three-dimensional, but a photograph is not. So how do you show the depth of a subject using an inherently flat medium? Try these strategies:

1. **COMPOSE** so the image has a prominent object/subject in the foreground, background, and middle.

2. **USE A WIDE-ANGLE LENS** or wide zoom setting for deepening effect.

3. **MAXIMIZE DEPTH OF FIELD** by closing down the lens aperture, using a wide-angle lens, or stepping back.

4. **POINT OF VIEW.** Shoot the subject from an angle, rather than straight on.

5. **SHADOW.** Include shadows in the frame, as you might use shading for volume when drawing.

6. **BACKLIGHTING.** Position the main light source behind the subject to darken and separate the subject from the background.

7. **SIDELIGHTING.** Place the main light to the side of the subject to create shadows and a sense of dimensionality.

Meg Griffiths took great care in placing her subject's head at the edge of the frame. In many cases this is easiest to accomplish when looking through an eye-level viewfinder, which shields the view from the sun in a way that a camera's viewing screen cannot, thus facilitating critical framing.

VIEWFINDER

With most compact digital cameras, you are limited to viewing on a display screen to compose your pictures. But many digital cameras also have a built-in eye-level viewfinder, which is often preferable. A viewfinder shields ambient light, which can be very useful, especially on bright days, when viewing on a screen may be difficult due to its dimness and reflections.

Another major advantage of an eye-level viewfinder is steadiness. It allows you to brace and steady the camera against your forehead when viewing. This is useful in many shooting situations, but especially in dim light without flash and with a slow shutter speed.

With display viewing, you're usually holding the camera away from you, which is inherently less steady because the camera is more subject to shaking during exposure.

Still, there are times when display-screen viewing is best—for example, when holding the camera up to shoot over a crowd. Just be mindful of camera shake and hold the camera (and yourself) very steady when pressing the shutter button. And if you have the camera on a tripod for, say, a landscape photo, some may prefer display viewing since it lets you view your subject somewhat like you might view a print—or an episode of *Orange Is the New Black*.

Film cameras still do a good job of image capture. The quality is wonderful, but the workflow is slow—too slow for most but just right for others. Witness this moody, introspective, soft-focus self-portrait from Rachel Jump.

WHY FILM?

Before digital cameras, cameras were analog and captured images on film. Some photographers still prefer film. In fact, film has been making a modest comeback recently. But why? Digital capture provides a much more fluid and seamless workflow. And it's much quicker to use and process. Not to mention arguably more affordable—no film or processing costs.

Some see the relative slowness of film photography as an advantage, arguing it makes for more careful compositions and more considered results. Others own a good film camera and have established a workflow they like. And still others like being able to see the process unfold in front of them.

And then there are those black-and-white photographers who simply like working in a darkroom, the amber-lit room where traditional photographic prints are made. Moreover, many museums and galleries prefer increasingly rare silver-based analog prints. After all, some people prefer analog music to digital. Think vinyl, for example. Most don't care, but some do.

A monochromatic look seemed to fit this abstract nude. Adding a brown/sepia tint in post gave it a vintage look—timeless and even less "real," perhaps.

BLACK AND WHITE

For the first hundred years of photography, almost all pictures were monochromatic—sometimes black and white and just as often shades of brown or some other color.

Some photographers still prefer a monochromatic look for their photos, seeing it as classic, timeless, abstract, moody, and even "arty." Color is often seen as more realistic, contemporary, and accurate. But black-and-white pictures can be realistic and color pictures can be moody. Ultimately, it's a matter of personal preference.

It's easy to convert digital capture (which is inherently in color) to black and white, either by setting it in your camera menu or when editing in post. If you set black and white in the menu for a JPEG alone, you'll lose the option to convert to color later, so shoot JPEG plus RAW. Your JPEG will give you an immediate black and white, while the RAW file will retain all the color information, which you can use as you choose in post.

Careful viewing and framing are hallmarks of Guillermo Srodek-Hart's work. Looking through the viewfinder, he makes dead certain the edges and corners of the subject align. And that he fully includes critical elements in the picture—the television and table on the left and the man on the right.

LAST LOOK

Just before taking the picture, take a last look around the viewfinder frame or LCD display. Check the edges for distracting elements, such as people cut off awkwardly or areas that are so bright that they might distract from the main subject. While you're at it, check the corners as well. It's important that the frame be well anchored, weighted so its edges bring the viewer into the heart of the picture—what's inside the frame, not on the periphery.

It's also worth a last look at your main subject. Is there a tree sticking out of your portrait subject's ear? Move yourself and your camera a little to the left or right to separate tree from head. Does the horizon in a landscape cut across too high in the frame—or too low? Aim the camera up or down a little, or raise or lower it, to reposition the horizon.

SUBJECT

"It's more important to click
with people than to click the shutter."

ALFRED EISENSTAEDT, PHOTOGRAPHER

Here's a portrait that uses humor and a busy but complementary background. The light is good, the color prime, and the composition to the point, but the subject is the ticket, as with most of David Graham's amusing take on all things American.

SUBJECT RULES

The most important element in a good photograph is a compelling subject. Some disagree. They might say that the idea behind the image is paramount—the conceptual message. Or maybe the color, scale, craft. All of these are important factors, but if the subject is boring, then it doesn't much matter how smart, large, or well-made the photograph is.

Naturally, what is boring to one person could be the very thing that compels another. That's the rub. Still, there are classic subjects that have retained interest to many over the years— beautiful landscapes, humorous scenarios, famous locations, celebrities, news, animals, sports, children, attractive humans. And, let's face it, nudity and pornography.

As the photographer, you get to make the call. But don't expect everyone to hear it and follow.

Michael Wilson is well known for his iconic portraits of musicians (and others) that grace album covers, posters, websites, and advertisements. His subjects are well known to his audience, though not always to the world at large—here, Audra McDonald, Broadway actress and singing megastar.

PORTRAIT SUBJECTS

Naturally your subject is extremely important. Portraits of actors, musicians, and models are popular because of their celebrity, not necessarily the photographer's skills. Famous subjects or not, people with a striking look usually make the best portrait subjects—people with prominent cheeks, bright red hair, conspicuous tattoos, wrinkled skin, big eyes, or strong necks. Or people who are simply drop-dead beautiful or handsome or somehow unusual, even weird looking.

Generally a subject judges a portrait's success by how good he or she looks. This is a subjective matter, of course. Some people want to look handsome, pretty, or sexy. Others will settle for serious, thoughtful, or warm. Consider these factors.

1. LOCATION
2. LIGHT—DIRECTION, QUALITY, COLOR
3. CLOTHES
4. HAIR AND MAKEUP—OR NOT
5. BACKGROUND
6. FRAMING

Brian Ulrich is well known for his work on consumer culture. This image of elderly shoppers uses their gestures and expressions, as well as their shopping cart, to place them in a background of groceries that speaks to mundane consumerism.

BACKGROUND MATTERS

Background distraction is often a matter of subject content—a scene that is just too busy. Perhaps a house in the background distracts when you are photographing a car, or a crowd in the background distracts from a float in a parade. But the distraction could also be from color or tonal similarities or differences. If your subject is wearing a red sweater, she will blend into a reddish wall; if she wears a blue sweater instead, she will stand out from the wall.

In black and white, color doesn't matter; tonal differences rule. So, a blue sweater and red background may render as the same gray. Place your subject in a dark sweater, whatever the color, against a light wall—or light against dark—though sometimes color and tonal closeness can be nice. So, if possible, ask your portrait subject to bring different clothes and ask her to change if need be.

"Photography is a way of feeling, of touching, of loving. What you have caught on film is captured forever . . . it remembers little things, long after you have forgotten everything."

AARON SISKIND, PHOTOGRAPHER

FEELINGS

A good photograph can express a wide range of feelings and emotions. Some are funny or energetic; others, sad or quiet. Much of this is open to broad interpretation, but generally strong, saturated color suggests energy, while a grayish, monochromatic palette and even black and white may suggest sadness or other more inward feelings.

Photographers often try to express a photo's feeling by capturing a particular gesture or expression. This is often easiest to accomplish by posing or staging your subjects but may be more convincing when captured spontaneously. Perhaps an emphatic hand gesture or an acrobatic subject in full flip. Or a despondent face with eyes looking downward, or a joyous expression of your subject in everyday motion.

Telephoto lenses (or tele zoom settings) have the effect of compressing close portrait subjects, and can help you defocus the background to minimize distracting elements. This works whether your subject is animal or human. Here, an f/2 aperture was used for even less depth of field, so the tongue would be in sharp focus and everything else soft.

PORTRAIT LENS

Moderate telephoto lenses (or zoom settings) are often rec-
ommended for portraits because the extra distance they put
between you and your subject has a mild compressing effect,
making features appear a bit more flattened. Wide-angle
lenses can have the opposite effect, making close subjects
appear more bulbous.

Background blur is another effect associated with telepho-
tos and often works well for portraits. In particular, when tele
lenses are used at close distances, they produce very shallow
depth of field. If you want to make doubly sure the background
is blurred, use a fairly wide lens aperture—say f/2.8 or f/4.

The best telephoto length for portrait work is about dou-
ble the length of your normal lens, or a little less. This varies
with the camera you're using. With cellphone cameras, the
default focal length tends to be somewhat wide, so zoom just
a little. Normal with APS-C sensor cameras is about 30mm, so
use about 60mm. With full-frame cameras, the normal focal
length is 50mm, so use about 100mm. With compact cameras,
find out what "normal" is and double it. Or just wing it.

"Photography gave me license to be on the front row of things . . . to explore places I might not have entered without a camera."

LARRY FINK, PHOTOGRAPHER

GET OUT OF HERE!

Some photographers travel to make their work, but many are stay-at-home shooters. You can certainly make good pictures locally in a studio or among your friends and in your neighborhood, but you'd be missing one of the joys of being a photographer—having different experiences and meeting new people. In fact, some professional photographers chose their careers in part because it's a perfect excuse to do just that.

Consider your camera an entrée into different worlds. And don't be shy about it. You may be more of a voyeur than a participant, but you still get to see, and sometimes engage with, otherwise unknown people and places. See a little of how others live, and maybe even make new friends and have some adventures.

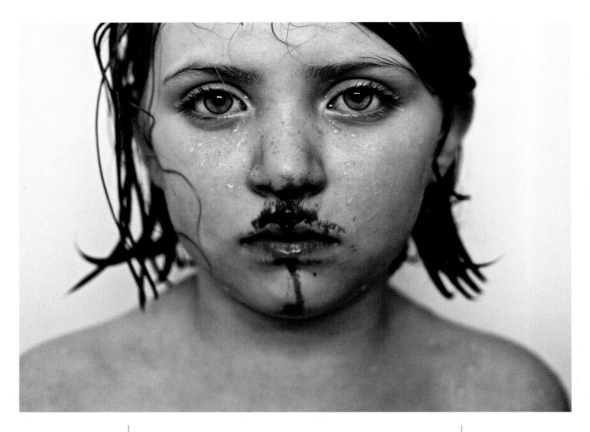

Jesse Burke photographed his daughter Clover over and over as they explored nature by land and by sea for his book *Wild and Precious*. His approach was natural—whatever the minor mishaps, Jesse was there to record them, not to cover them up.

MUSINGS

Sometimes subjects reveal themselves naturally. A positive person may smile; a depressed person may scowl. But photographers can often make choices that emphasize a point. A lush, natural setting helps create a warm, cozy feeling; an urban slum may do the opposite. Bright-colored clothes may make a subject seem upbeat; dark clothes, not so much.

Posed pictures are more formal than candids, which suggest spontaneity. And then there's expression. A natural smile says something; a forced smile says something else. Gestures are also revealing. A closed fist may be aggressive; crossed arms, defensive; covered eyes, sad or frustrated.

Usually, a portrait includes a person's face, but it doesn't have to. You can shoot the back of a person's head or their feet or hands. Bed head may suggest a casual subject; the same for crossed legs. Clutched hands say stress or distress.

Then there's distance to subject. Close views are more intense and intimate—even weird or threatening. The farther away, the more removed. In this way, portraits mimic real life.

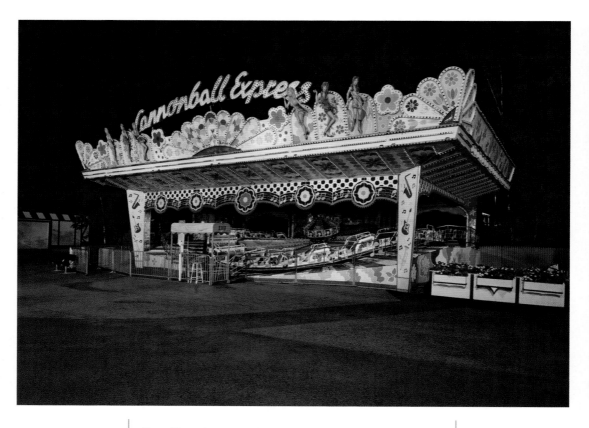

Great files rule, and professional photographers know that. Bill Hannigan shoots his *American Amusement Parks* series with a camera that takes 4×5-inch film, then processes and scans the film to make sharp and detailed large (and small) prints.

SCAN IT

For maximum image quality, especially if you want to make giant prints, use a large-format camera. The large size of the image sensor allows you to capture an incredible amount of detail, sharpness, and a range of colors. However, the price of the camera is sure to keep you in debt. A good medium-format camera can cost at least as much as a good used car—or more.

Alternatively, you can use an old-school medium-format (or large-format) film camera, scan the resulting negative, and make digital files the size equivalent (or more) of those produced by a medium-format digital model. Scanning is an extra step, but used medium-format film cameras are available relatively cheaply. Use the best scanner you can buy, or borrow one. Flatbed models optimized for film are good. Dedicated film scanners are often better. For the absolute best quality, have your images scanned by a custom lab that uses a drum scanner—long the standard in the offset printing industry.

YOU

''What we see is what we are.''

GRAZIA NERI, PHOTO EDITOR

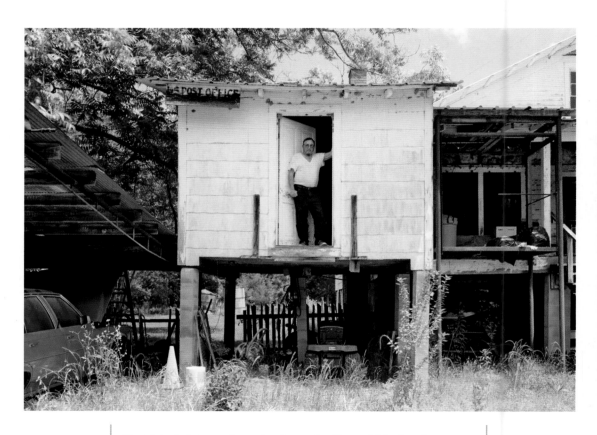

For a lot of photographers, shooting unfamiliar neighborhoods or areas is both productive and a good way to learn about a different world. For Rachel Boillot, it's a passion and a career as a photographer and folklorist exploring the people, places, and culture of East Tennessee.

DIG A LITTLE DEEPER

When traveling, casual photographers usually take pictures of their traveling partners, an historical monument, or a seaport. These are important records of your time away and can also be noteworthy images on their own. However, a little more effort may allow you to dig a little deeper into local culture, have a richer experience of the area's character, and probably make better pictures.

Take a little time to walk around and explore less obvious situations and neighborhoods. Shoot buildings, signs, windows, meals, and interiors—even the locals, if you dare. Shoot candidly and even from the hip, if that makes you most comfortable. But sometimes making yourself obvious is the best tactic. When potential subjects see you with your camera, they will probably figure out that you are there to take pictures. If they don't want to be photographed, they may say so or make themselves scarce. If they don't care, or even like to be photographed, they may stick around for you to do your thing.

BACK IT UP

You've heard it before. Perhaps you've even said it. "I can't find my memory card." Or, "I think I dropped it in a glass of Guinness." However it happens, you've just lost a lot of time and maybe some good pictures. Safe storage is critical with digital capture.

Back up obsessively. It's a tedious task and easy to put off. But resist that laziness. Do it right away—preferably every day you shoot, but certainly every few days. As soon as you get home from shooting. Even before you have that fatal beer.

There are several good backup strategies, but the best one of all is several backups. The problem with hard drives is that they often fail, except the more reliable and expensive solid-state kind. So, buy two or three hard drives, mirror them, then place them in separate locations in different "homes" for safety. Make sure the locations are as fire- and waterproof as possible (no potentially flooding basements, for example).

There are also many good Cloud storage options. Use one from a well-known company. One that might still be in business in a few years. Startups are cool, until they shut down.

AFTER SCHOOL

Workshops are a reasonably affordable way to continue your photography education after school—or in lieu of school, or while on hiatus. The atmosphere might be intense or loose, depending on the place, but it's almost always a good time and good learning experience—and might even give you some good networking opportunities.

Workshops come in all forms and costs, but a typical one might run for a weekend or a week and concentrate on a particular technique, for instance studio lighting or video editing, or a visual style, perhaps in fashion or landscape. Some workshops are taught by professional teachers and others by well-known professionals who only teach in workshop settings.

Local photography centers, camera clubs, and even camera stores often run workshops, and there are a number of workshop-only venues. These are some of the best known:

ANDERSON RANCH ARTS CENTER
Aspen, Colorado, USA
www.andersonranch.org

MAINE MEDIA WORKSHOPS + COLLEGE
Camden, Maine, USA
www.mainemedia.edu

PALM BEACH PHOTOGRAPHIC CENTRE
West Palm Beach, Florida, USA
www.workshop.org

SANTA FE PHOTOGRAPHIC WORKSHOPS
Santa Fe, New Mexico, USA
www.santafeworkshops.com

One of the most influential photo communities ever was The Photo League (1936–51) and Erika Stone was one of many legendary photographers it attracted. One thing the Photo League did was group projects, in which a number of photographers would go to a designated area or find a certain subject and shoot. Community.

COMMUNITY

Bicyclers often bike in packs. Golfers team up in foursomes. Poker players need other players to make a game. But photographers usually work alone. Most of the time it's for the best— fewer distractions and more attention to photographing, editing, printing, or posting it.

Still, most photographers do need to share information, receive feedback, and generally have sources of motivation. Schools provide an easy community—teachers, fellow students, facilities, support, and equipment. But if you're not in school, you're pretty much on your own.

Fortunately, there are many paths available for building your own photography community—sort of informal replacements for school. Here are some options:

1. **PHOTOGRAPHY CENTERS.** Nonprofit spaces, and even some camera stores, that sponsor lectures, classes and workshops, contests, portfolio reviews, and other programs.

2. **CAMERA CLUBS.** The original photography centers, many are still active.

3. **CLASSES.** Learning, plus an affordable way to gain access to a digital, or maybe even an analog, darkroom class.

4. **INFORMAL CRIT GROUPS.** Takes initiative, planning, and ongoing resolve, but can be fun.

5. **WORKSHOPS AND PORTFOLIO REVIEWS.** Flexible timing with limited time commitment.

"There's nothing more extraordinary than reality."

MARY ELLEN MARK, PHOTOGRAPHER

AMAZE ME

The legendary art director of *Harper's Bazaar* magazine Alexey Brodovitch (1898–1971), supposedly sent aspiring photographers away with this homily: "Come back next time and amaze me." These days, good pictures aren't a dime a dozen; they are a penny a thousand. Lots of terrific photographers out there. How are you going to stand out?

Think about the photographers you like. Or, for that matter, writers, filmmakers, and anyone else in a creative field. What draws you to their work? Maybe it's the way they tell a story or their style of telling it. Often it's their subject matter—landscape, sports, news, or celebrity. Or it could be their "message"—what their work speaks to, perhaps politics, spirituality, or even humor.

So many variables, but there is at least one thing that most admired "artists" have in common. Their work is somehow unique to them—identifiable. When you hear the first few notes of an unfamiliar song, you may be able to recognize the musician. And when you see a few unfamiliar pictures, you may be able to recognize the photographer. Somehow the musician and photographer have made themselves recognizable in great part because what they do is different from what others do.

This Mathew Brady photograph of Abraham Lincoln is an obvious history. But you have your own archive in your Instagram or Facebook account of friends and family who have contributed less to the nation but significantly more to your life—your personal history.

HISTORIES

Taking a picture is capturing time as it is—at a moment. Actually a fraction of a second. But a picture ages with time. Photographic prints may actually change color or tones, fade, or stain—even when handled correctly. But while the physical change is easy to predict, the more important changes are far more difficult to pinpoint.

You don't know how you'll look in ten or twenty years, but you most definitely will look different. So will your friends, family, and everything else around you—from your hometown to your hairstyle. Not only will everyone look different, but your memory of him or her will have changed as well.

This makes photographs important historical markers of your personal history, not to mention history in general—such as political events, celebrities, even disasters. Sure, they don't preserve everything, but they do form a record of physical attributes—what people look like and when—and memories. And for all these reasons, and more, it's important to make good pictures now and to preserve them for the future.

Sometimes a second or two makes all the difference.
Here, the tiger could have stopped posing and become
hostile. Getting the picture took patience and reflexes—
and common sense.

PATIENCE

A lot of photographers work on the run. See a subject, focus, snap—and onward. But a little patience can go a long way to making better pictures. Some suggestions:

1. **WORK YOUR SUBJECT.** Don't take just one quick shot. Take several—candid, posed, different light, different location. Be very mindful of the edges and corners of the frame.

2. **WAIT FOR THE PICTURE TO HAPPEN**—for a good subject to pass by or make a gesture or walk in front of an interesting sign or hug an old friend.

3. **COME BACK** and reshoot, if necessary.

4. **TRY AGAIN.** Sometimes your first effort fails. The light is bad, the subject's expression is goofy, or the settings were off. If you still like the picture idea, go back and try again, if possible. Make sure everything in the frame belongs there. If something doesn't, walk or zoom closer and crop it out before shooting.

Legendary bluesman Gatemouth Brown lived in this
house, drove this car, and dressed in these clothes.
There was no need to "style" him—just photograph
him as he lived. Natural.

GO NATURAL

Staging photographs has always been popular, whether it's amateurs moving family members around or pros building sets and styling models. Similarly, in the fine-art world, staged imagery is highly popular, as photographers create tableaux that mimic and comment on real-life situations or that have nothing to do with reality.

These are time-tested ways to work, requiring imaginative and creative minds. But there's another way, which is much more obvious. Reality. Unfettered. Natural subjects, captured as they are. Humans, animals, and landscapes are naturally amazing enough. It's hard to make this stuff up. Everyone is different. The same goes for every place and action—whether crowds on a sidewalk at rush hour or a 10-year-old sliding into home plate.

Most good photographs are about good subjects. They aren't overthought or overwrought. Find a good subject and capture it, in the right light and framed well, and there's a good chance you'll have a good result.

SLOW DOWN

In life, sometimes you have to slow down a bit to think and to make decisions. The same goes for taking pictures. Stop shooting reflexively, consider your subject carefully, and then shoot. You might find a better subject, a tighter cropping, or a more interesting point of view. Or something or someone may enter the frame and add unexpected interest to the picture. Maybe the natural light will change and become richer or more subtle, or daylight will descend into darkness and the city lights will take over, creating a totally different landscape from the exact same subject.

Shooting quickly may guarantee you have your subject in hand. Then, relax. Hang around and consider other options—or allow other factors to introduce themselves. Maybe you are on a beach, taking a seascape. Stick around. Someone might walk by and start a conversation, which might lead to an interesting portrait opportunity—or maybe even a new drinking buddy.

RULES

Some photographers like rules. They want to know what makes a good picture and how they can achieve it. No surprise, but here's the big secret: There are no rules, really. Every photographer is different and every subject should be viewed differently.

Of course, some people will always try to make rules. One example is the Rule of Thirds, which divides the picture frame into nine equal parts and says important subject areas should fall on those lines, effectively saying: Follow this rule and your pictures will look like the pictures of every other Rule of Thirds follower. Predictable. Or worse.

Forget the rules. Or better still, make up your own and give it a shot. Go to any photography class, workshop, or club and look around. You will see a lot of people like you—passionate shooters with some ability, many of whom think they have something to say. How do you separate yourself from the rest? Beats me, but probably not by following the same rules that everyone else does.

Simple ways of working and simple subjects are often the best routes to good photos. Here, a cool-looking sign, rich light, and striking color.

SIMPLE

Sometimes photographers fret over what subject to shoot or how to start a project. They get stuck. It can be complicated, but it doesn't have to be. Here are seven guidelines for simplicity.

1. **PICK A SUBJECT.** It should be something you care about and maybe something that can engage you for much more than a shoot or two.

2. **FIGURE OUT LOGISTICS.** Where, when, and who you have to photograph and what you need to make it happen.

3. **FIND GOOD LIGHT FOR THAT SUBJECT.** Direct, backlighting, sidelighting, whatever.

4. **SET YOUR ISO.** Low on a bright day or high in low light—or select AUTO ISO.

5. **SET YOUR EXPOSURE,** or aperture priority (if depth of field is your main concern) or shutter speed priority (if sharpness or blurring is your main concern)—or set on automatic if none of this matters to you.

6. **COMPOSE.** So that everything within the frame belongs, avoiding extraneous detail. Take a last look around the corners and edges of the frame to make sure you have what you want and not what you don't need.

7. **DO IT!**

Barbara Nitke has had a robust commercial career, shooting for television, fashion, and film clients. But her personal work is invigorating, fun, and can even help redefine a working style, such as her current *Smooth Hotel* series.

PERSONAL WORK

You could say that every picture you make is personal. After all, you took it. Your images may be a random lot of portraits, landscapes, events, travels, and so forth—using a variety of styles and approaches. But most skilled photographers will start to develop a consistent vision. Think of your favorite musicians or novelists, for instance. Usually, they have a coherent message, delivered in their own signature style, even as specifics and subjects of the work may vary.

Obviously not all photographers will meet these lofty standards. Most photographers aren't that concerned with subject or style consistency. But over time, your particular way of seeing may come out naturally, without your really trying. You will be drawn to certain subjects and certain ways of approaching them—close, distant, candid, whatever. And if you photograph for a while, the good images will just "pile up," as legendary photographer Harry Callahan used to say. In time, you'll have your own archive—a collection of (hopefully) strong photographs made over the years in your own particular way.

"You gonna do what you got to do to get what you want."

BERTRAM COOPER, FROM TV'S *MAD MEN*

BELIEVE IN YOURSELF

There's no shortage of opinions when photographers are involved—everything from what camera is best to how to frame a portrait. Asking questions and showing your work around are great ways to learn and stay engaged. Talk to lots of people; read reviews, books, and blogs; or take a class. Absorb what you learn, mix it up, and then draw your own conclusions.

Of course, there is some information that's irrefutable. If someone tells you that a lens open to f/4 lets through more light than a lens set to f/11, or that shooting at ISO 100 will give you better-quality pictures than shooting at ISO 2500, you can take that to the bank. But if someone tells you that everything in a picture needs to be in focus, or that you should always use a flash in low light, or that you shouldn't be photographing one thing or another, you should probably process that information and decide for yourself whether this advice applies to you. It may. Or it may not.

Unpredictability plays a big part in the work of still-life/fine-art photographer Gisel Florez. "I like to play with the moment between the shutter and sensor," she says. By moving the camera during her exposures, which are often several seconds long, she achieves effects not possible with a conventional approach— here, unidentifiable shapes caused by strong light illuminating the scene.

BE UNPREDICTABLE

Some of the best photographs out there are predictable. The subject may be standing in the middle of the frame, staring blankly at the camera. Or just goofing around to impress you, trying to take control of your shot. Even with a static subject, photographers can make the mistake of thinking there's only one way to shoot it.

But a little unpredictability in your photographs can be refreshing. Don't wait for your subjects to pose—catch them off guard by shooting before or after the "official" picture. Let the dog wander into the frame, even if he blurs. Maybe even set a slightly slower shutter speed so all the commotion will blur. Try placing subjects off-center in the picture, so it's not just about them. Shoot with the camera tilted. Or even shoot "from the hip," without looking through the viewfinder.

Some of the greatest photographers out there have used these simple strategies. Your success rate with them will be lower than usual—but when they work, they can give you an image that turns unpredictability into originality.

SHARE

"The best way to avoid being sued is to stay broke."

MARK FISCHER, LAWYER

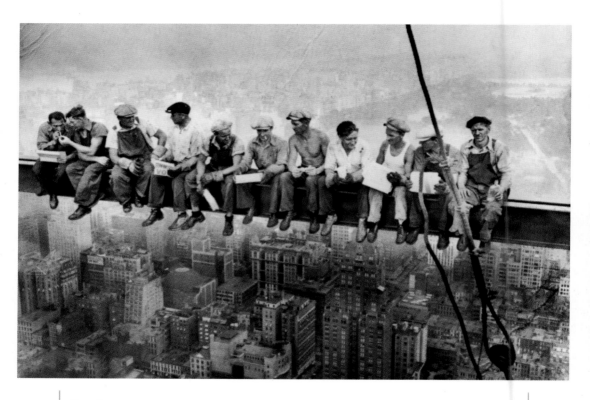

Not all vintage prints are valuable, but some are. This Lewis Hine image is a case in point. Old (vintage) prints sell for thousands of dollars (and more). But you can get a modern print (of this and many other photographs) from the Library of Congress, where much of his work is housed, for a few bucks. You can even get a hi-res file you can use to make your own print. Same image. Possibly even a better-quality print. But not vintage. *www.loc.gov/pictures/*

VINTAGE

Whether you're talking about vinyl LP records or fashion, vintage is really just another way to say old. And old is in. Sometimes.

In photography, vintage could mean such things as an older visual style or subject or an older technique, such as the 19th-century wet-plate process. Printing black and white and shooting with film may also qualify as vintage, if prints are less than a few years from the time the picture was made.

Photography collectors, dealers, and museums like vintage prints and other materials for another reason. They are usually more rare and therefore more valuable and/or profitable. Older prints made within a few years (about five) from the time they were taken are usually considered vintage, though this is a rather loose rule. What makes old prints more valuable is their rarity. You can push out modern prints of older work, but you can never make old prints again. That train has left the station.

PERMISSION FOR PHOTOGRAPHY

For valuable consideration received, I grant to *fill in your name* and his/her legal representatives and assigns the irrevocable and unrestricted right to use and publish photographs of me, or in which I may be included, for editorial, trade, advertising, and any other purpose and in any manner and medium; and to alter and composite the same without restriction and without my inspection or approval. I hereby release Photographer and his/her legal representatives and assigns from all claims and liability relating to said photographs.

In most countries, you can take pictures in any public place, but you may need a model release to use them, at least for commercial purposes and profit. There are many apps available that allow you to take a picture of your subject, fill out your subject's contact information, have them sign, and more. Or just use this form from the American Society of Media Photographers. Make sure the subject's contact information is listed (address, email), sign it yourself, and have it signed by the subject and a witness.

MODEL RELEASE

In most cases, you can take all the photographs you want of whomever and wherever. But how can you use them? This gets complicated, but it mostly comes down to your purpose. If the pictures are for commercial use, you'll need a signed model release. But you probably don't need a release if they're for magazines, newspapers, books, websites, blogs, or galleries.

There are several caveats to this. You'll need a release if the picture is taken in a place where a subject has a reasonable expectation of privacy. Or in which the subject's clothes are off, for (an extreme) example if they are having sex. Or when the image could be seen as libelous. Or when children are involved.

Speaking of children, minors have to sign a separate minor release that parents sign too. There are also specific releases for houses and other property you might be shooting, including pets, which are considered property by law.

"Criticism may not be agreeable, but it is necessary. It fulfills the same function as pain in the human body. It calls attention to an unhealthy state of things."

WINSTON CHURCHILL, FORMER BRITISH PRIME MINISTER

REVIEWS

A great way to learn is by having photography professionals review your work. But it's hard to get a working pro to do that. Most are too busy to sit with strangers and give them feedback. That's where portfolio reviews come in.

Typically, a group of reviewers come to a set location, and photographers pay a fee for short (say, 20 minutes) review sessions. You go from one reviewer to the next and get a cold read on your work. It's sort of like speed dating.

Expect direct questions, bluntness, and disappointment. But it's a way to connect with people you'd never meet otherwise—photographers, teachers, publishers, magazine/zine editors, museum curators, and gallery owners.

Go in with a thick skin and low expectations. You may be surprised. Probably you'll get just advice and opinions, but there's an outside chance you'll get work in a show, a book, or a blog or, much more rarely, sell a photograph. At the least it will help keep you engaged, motivated, and otherwise involved.

Photographs
& The Enduring Image:
The Collection of Dr. Saul Unter
New York, 9 April 2018

PHILLIPS

Phillips and other auction houses have regular sales of original photographs, such as the Rudolf Koppitz here. A print by famed contemporary photographer Andreas Gursky was sold for about four million dollars a few years ago. A vintage shot by Man Ray went for about the same amount more recently. Presumably someone wrote a check to pay for them.

ART IS COMMERCE

Art is commerce, at least to some degree. Most artists don't talk about it, or like to think about it, but that doesn't make it untrue. Commerce is the exchange of money for goods or services. If someone paid for it, then commerce happened.

Did you ever sell work in an art fair or gallery or to an individual? Many photographers try, and when it works out, commerce happens. On a more lofty scale, have you seen a major museum show, or for that matter a museum, with no corporate sponsorship?

Sponsorship has consequences on what kind of photography gets exhibited. What you see. What gets attention. Can you imagine, say, an IBM-sponsored show with a high degree of political or sexual content?

In days past, photographers used this symbol to indicate that they owned all rights to the image. It's no longer needed by law, but it's not a bad idea to remind the viewer that you are the sole owner of the image.

OWNERSHIP

This is not official legal advice, since it doesn't come from a lawyer, so take what follows with a grain of salt. But some things are pretty clear-cut. First and foremost, if you take a picture, you own it. You automatically have a copyright. Unless you sign it away to a client or someone else—an agreement called work for hire. And with some exceptions (educational use, etc.), no one can copy or use your photo without your permission.

In theory. Of course, photographs are stolen all the time. Posted on the web, in blogs, whatever. Most of the time, who cares? It can even be a good way to get attention for your work. But if, say, Apple wants to use your photograph, copyright is useful to hold their feet to the fire. And to get paid. And to control the use of your image.

While not absolutely necessary, registering your copyright is recommended. If you win your case, the court may award more money and also direct the thieving party to pay your legal fees. Lawyers like the sound of that, and are more likely to take on a case involving registered photographs.

Registration is cheap and easy to do. And you don't have to register each image individually. You can register a collection of many images. See www.copyright.gov for details.

TITLE IT

Always title your photography series—and individual pho-
tographs. Books have a title. So do movies. And music. Ti-
tles can help a lot in reaching an audience and helping them
understand what you're up to and what the series is about, al-
most like a mini artist's statement. And it's also a way to brand
it. A way people will remember and refer to your work—and
you. That's how the star photographers roll. Why not you? *The
Americans* by Robert Frank; *Immediate Family* by Sally Mann;
Solitude of Ravens by Masahisa Fukase.

You can make up your title yourself, or crib it from a book,
movie, or music that you like. Best not to make it too long,
usually. Avoid the obvious clichés and corniness, unless you
are into irony. And subtle is good. But not too subtle. A title is
meant to be helpful, not an inside joke.

GALLERIES OR STORES?

There are actually two (or more) types of galleries: nonprofit and commercial. Nonprofits are like little museums. Usually funded by grants and private donations, they typically have a curator who makes most decisions based not on what work will sell, but what work serves its community, has a particular view, or is from an artist deemed worthy. Sales of work may happen, but that's not what drives nonprofits.

Commercial galleries are another matter. They exist primarily to sell work, much like a shoe or other retail store. That doesn't mean the work they show is good or bad. It means it's intended to be sellable. Presumably.

Good commercial galleries show generally good work, of course. And many have gained their reputation and collector base by creative choices in what they show. Some are known for vintage work, others for contemporary. But sales are the focus, and if they don't attract paying collectors, they are out of business. It's a cold fact.

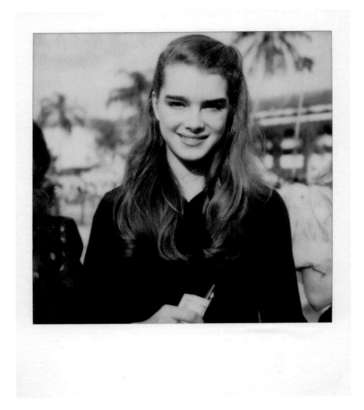

Polaroid and similar films look great, but they are generally less archival than other materials, in large part because all the (toxic and other) chemicals used stay in the final image; they are not discarded. This image of Brooke Shields is showing its age—almost forty years old. The once-vibrant color has faded. On the other hand, it makes the image look vintage. Which, of course, it is.

ARCHIVAL MATTERS

The term "archival" is used to describe the longevity of photographic materials and media. It basically means long lasting, and fade- and stain-resistant—suitable for an archive.

1. **STORAGE MEDIA.** Solid-state hard drives are more reliable. Cloud is reliable only if the company will be around for a long time.

2. **PRINTING PAPER.** Use a paper free of harmful acids and/or made from 100% cotton.

3. **INKS.** Pigment-based inks, rather than dye-based, are considered most permanent for inkjet prints.

4. **LIGHT.** Strong light, especially from UV-rich sources like sunlight, can cause image deterioration.

5. **FOR PRINTS,** store using archival envelopes/boxes/albums, made from safe, non-acid materials.

6. **HEAT, HUMIDITY, ENVIRONMENT.** High heat, high humidity, and unusual environmental conditions can affect a print's longevity—and possibly that of storage media. And keep prints and other media out of the attic, basement, laundry room, or any other place that might get especially hot or high in humidity.

THAD RUSSELL PHOTO

Websites are the simplest and most effective way of getting your work seen by a broad (and international) viewing audience. You can hire someone to design your site or do it yourself with one of any number of low-cost templates available from online suppliers. Make the design simple and striking and the navigation quick and intuitive, as with Thad Russell's site. Looks good. And to the point.

BUILDING A PORTFOLIO

Once the only way to show a portfolio of work was with slides (positive film images) or prints in a box or sleeved in a presentation folder. You can still do this with analog or digital prints, but you can also choose to show work digitally on a screen—a tablet, laptop, or even a cellphone. Most deciders (editors, art directors, gallerists) are fine with that—at least as a first pass.

Regardless of how you show your work, there are still critical matters, such as what work to show. Here are some suggestions.

1. **SHOW WHAT YOU CONSIDER YOUR VERY BEST WORK.** Don't make assumptions about what your viewer might like.

2. **SHOW DIRECTION, NOT VERSATILITY.** Pick images with a coherent theme, subject, or style.

3. **MAKE A TIGHT EDIT,** maybe fifteen to twenty images. More won't help; less looks lame.

4. **SHOW CONFIDENCE IN THE WORK,** especially if you are showing it in person. There's no reason to give doubt and also no need to be boastful. Let the work speak for itself.

5. **MAKE YOUR PRESENTATION NEAT** and convenient for viewing. Straightforward, fast, and simple.

6. **BUILD A WEBSITE** as the primary way to show your work.

ARTIST'S STATEMENT

Today it's expected that an artist make a statement about his/her work. If you are in school for photography, you may well be assigned to write one. You'll need one if you are applying for an exhibit or a grant. Regardless, it's probably a good idea to have one on hand in case it's needed and perhaps to post on your website.

A good artist's statement can give clarity to your work and to what you're thinking. It could even help you focus and better understand what you're getting at. A bad artist statement can confuse and sound really pretentious.

Don't overwrite. Be straightforward and direct. Explain, don't confuse. Be humble. But no humble bragging. Something like this:

"I take photographs of (fill in) that try to show (fill in). I'm interested in the subject because (fill in). In making the work I was influenced by photographers who work in a similar style and whose interest in (fill in) resonates with me—photographers such as (name some). I hope that the work will make viewers feel (fill in)."

IT'S OPINION

Photographers are rarely short of opinions, and many are about the work of other photographers. If you want to show your work around, you'd better grow a thick skin. Whether it's in class, informally, or on social media, other photographers often have strong opinions, and you'd better be prepared for it.

Actually social media sites are usually the kindest. Beautiful shot. You look great. Wow, awesome. But crit classes can be brutal. It depends who's doing the critiquing and maybe what they've had for breakfast. If someone hates landscape work, it's likely you won't overcome that prejudice, no matter how amazing your landscapes are. If someone believes all photographs should be horizontal (and some photographers do), good luck with those verticals.

Crits can sometimes seem useless, but they are often helpful. Especially if you understand it's mostly opinion. Informed and well meant, hopefully. But opinion, definitely.